OddScape BookFactory Presents

Mr. MothGurgle's Hideous Tales Of Preposterous Nonsense

By: Sam Higginbotham Jr.

Mr. MothGurgle's Hideous Tales of Preposterous Nonsense
Copyright 2012 Sam Higginbotham Jr.
Title ID: **3793437**
ISBN-13: **978-1470045739**.

For Alfie
&
Thanks dad.

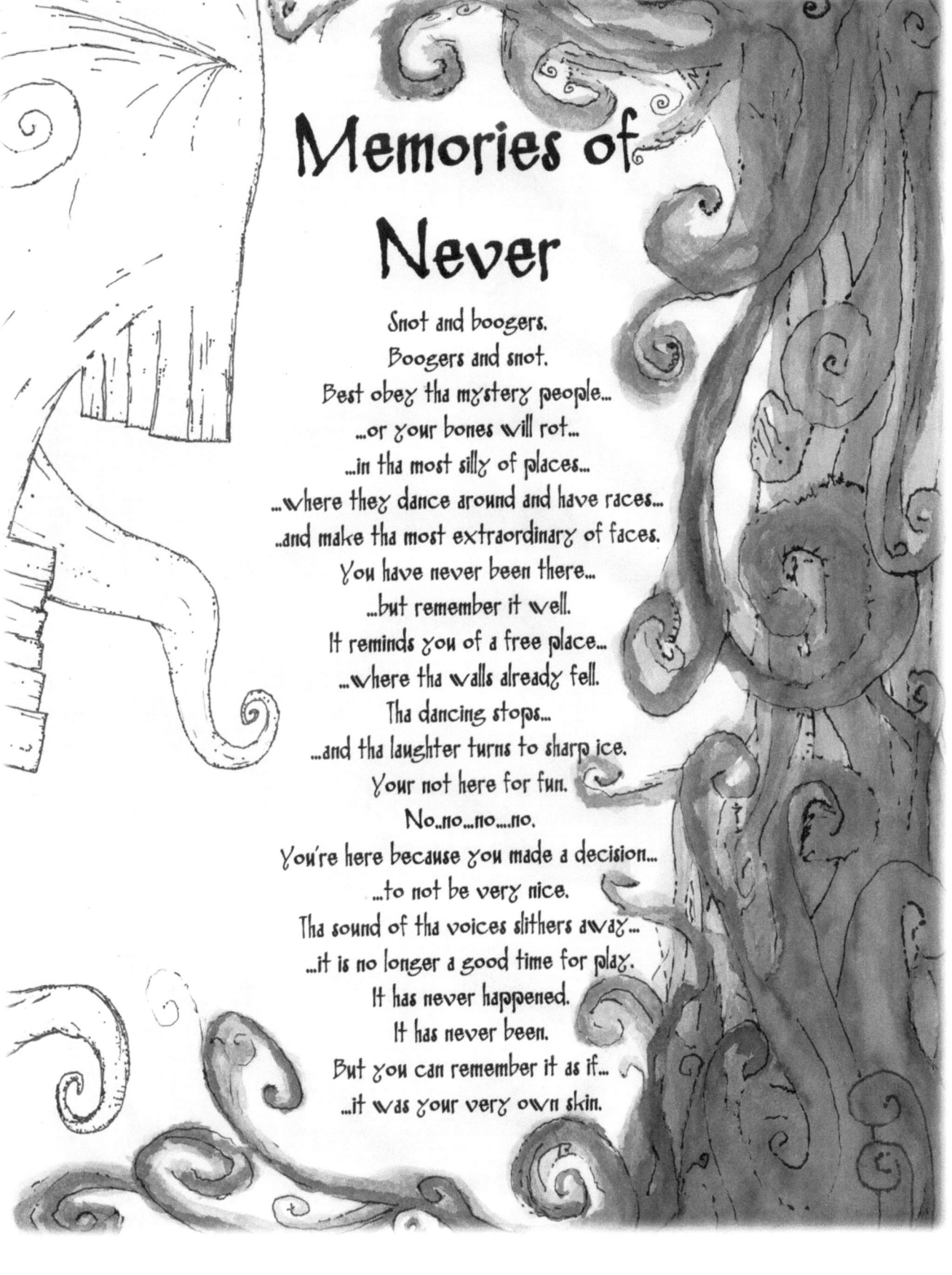

Memories of Never

Snot and boogers.
Boogers and snot.
Best obey tha mystery people...
...or your bones will rot...
...in tha most silly of places...
...where they dance around and have races...
...and make tha most extraordinary of faces.
You have never been there...
...but remember it well.
It reminds you of a free place...
...where tha walls already fell.
Tha dancing stops...
...and tha laughter turns to sharp ice.
Your not here for fun.
No..no...no....no.
You're here because you made a decision...
...to not be very nice.
Tha sound of tha voices slithers away...
...it is no longer a good time for play.
It has never happened.
It has never been.
But you can remember it as if...
...it was your very own skin.

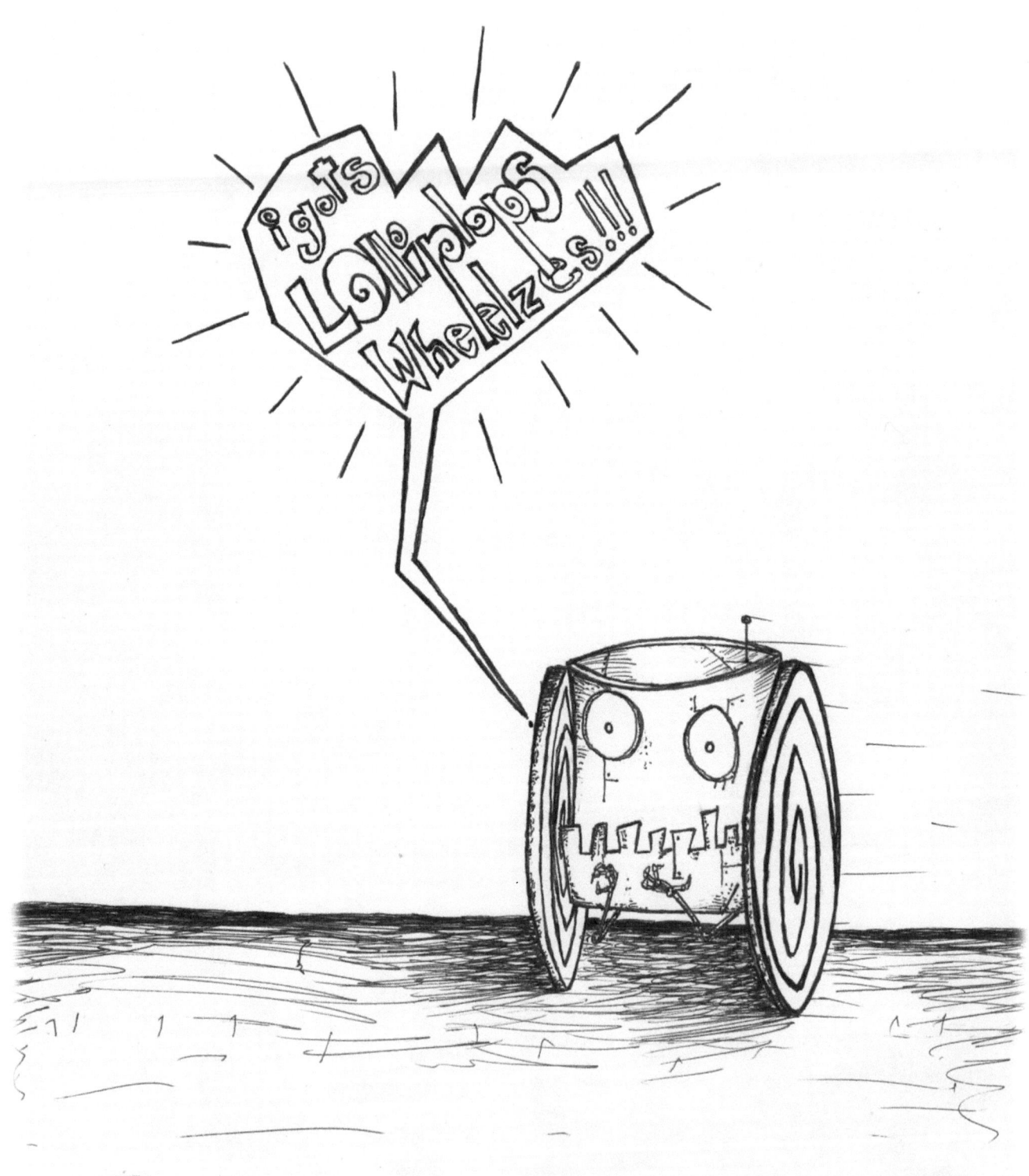

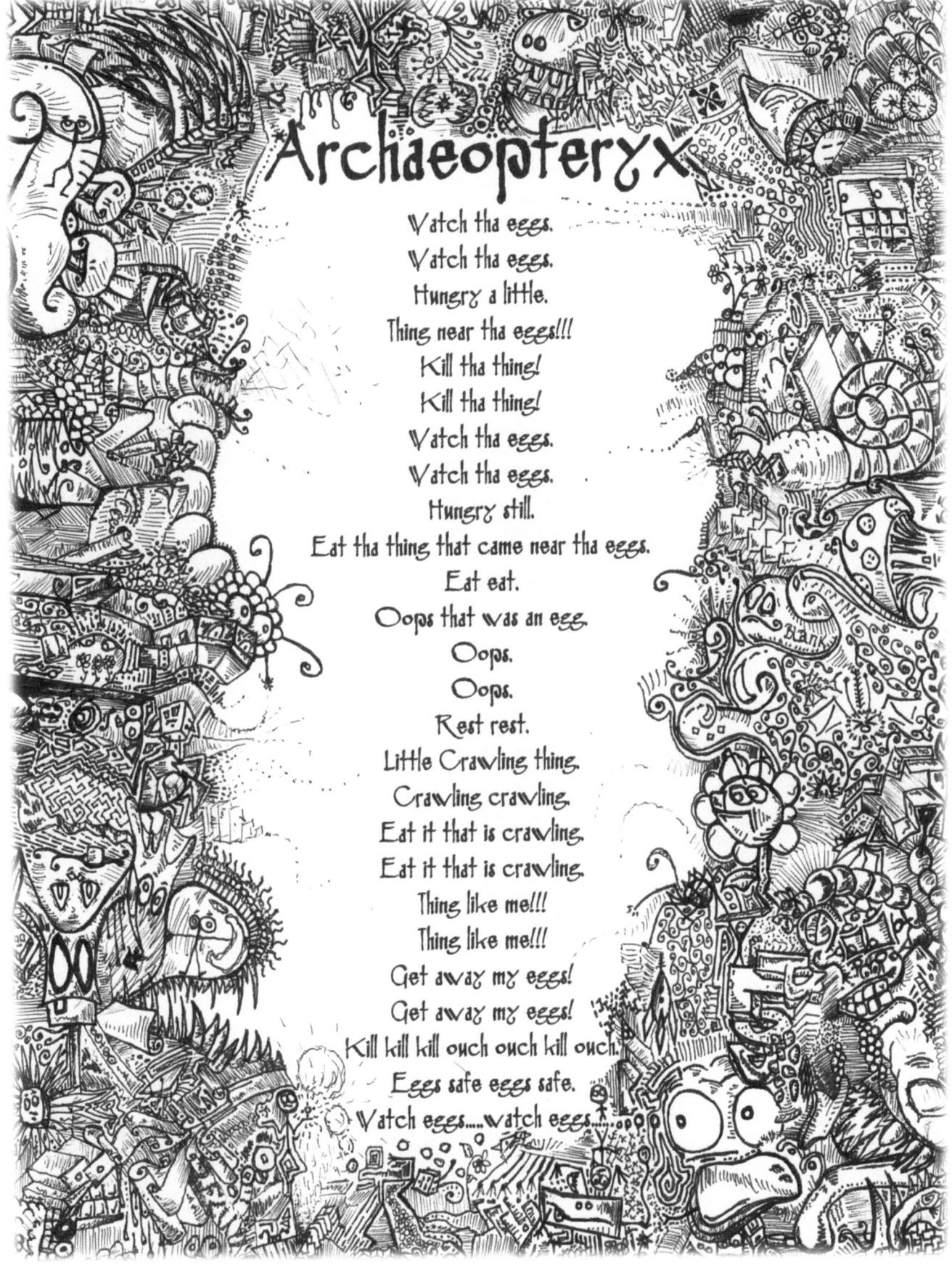

Archaeopteryx

Watch tha eggs.
Watch tha eggs.
Hungry a little.
Thing near tha eggs!!!
Kill tha thing!
Kill tha thing!
Watch tha eggs.
Watch tha eggs.
Hungry still.
Eat tha thing that came near tha eggs.
Eat eat.
Oops that was an egg.
Oops.
Oops.
Rest rest.
Little Crawling thing.
Crawling crawling.
Eat it that is crawling.
Eat it that is crawling.
Thing like me!!!
Thing like me!!!
Get away my eggs!
Get away my eggs!
Kill kill kill ouch ouch kill ouch.
Eggs safe eggs safe.
Watch eggs....watch eggs....

Findings...

"And tha beast, sitting inna dark space, like a great baboon, as in large and of uncommon size for a baboon, drenched in dark gooey blood, also sitting in a pool of, swung tha infant of its kind around in slow motion by its cord. Screaming and howling it spun tha young one around and on occasion bashed it into tha pool."

Translated from text in ruins of unknown origin in tha far fields near tha northern mountains of Kai-muhr. Translation by Dr. Heglyn of PublicSystems of Veldinahstra city.

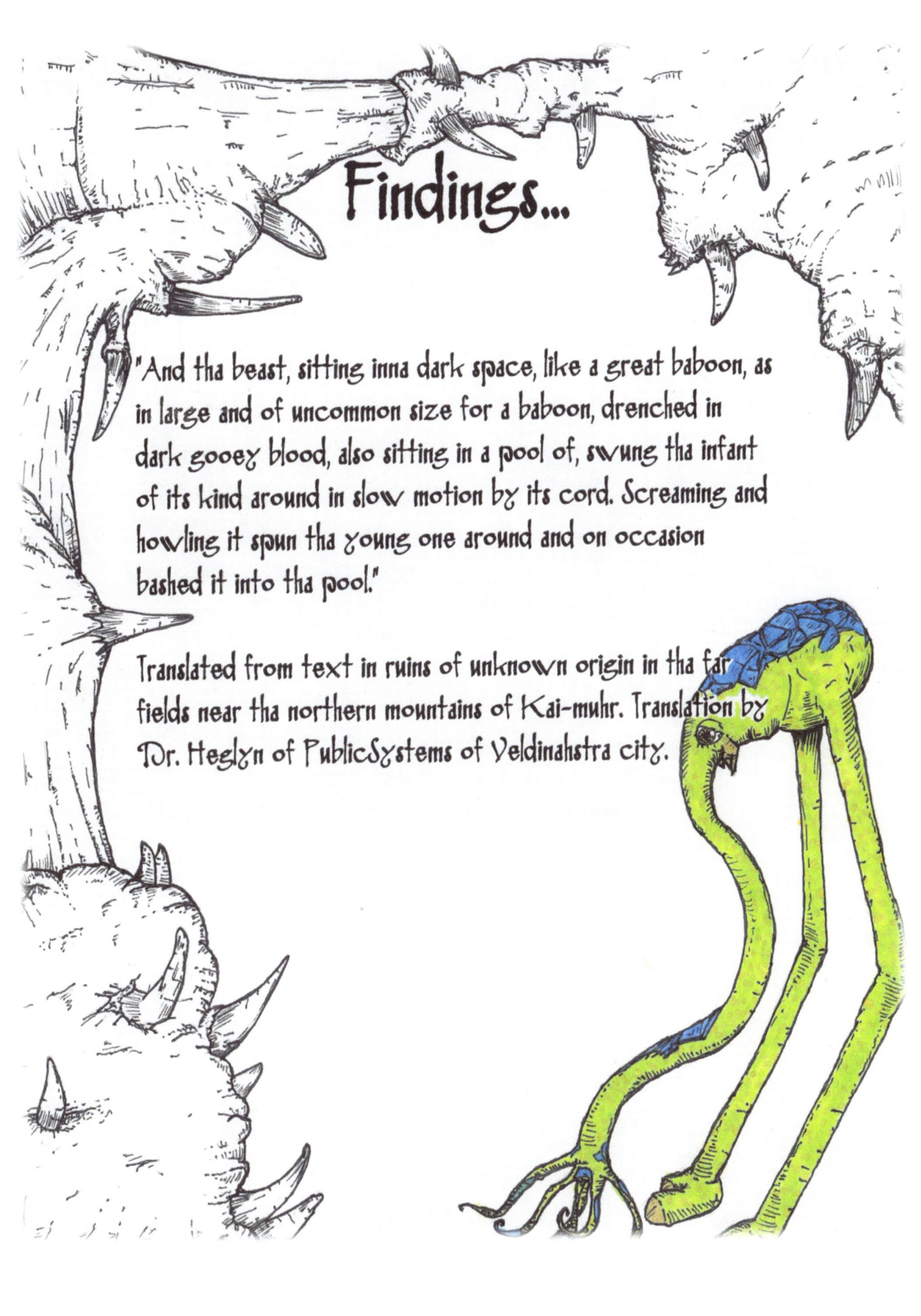

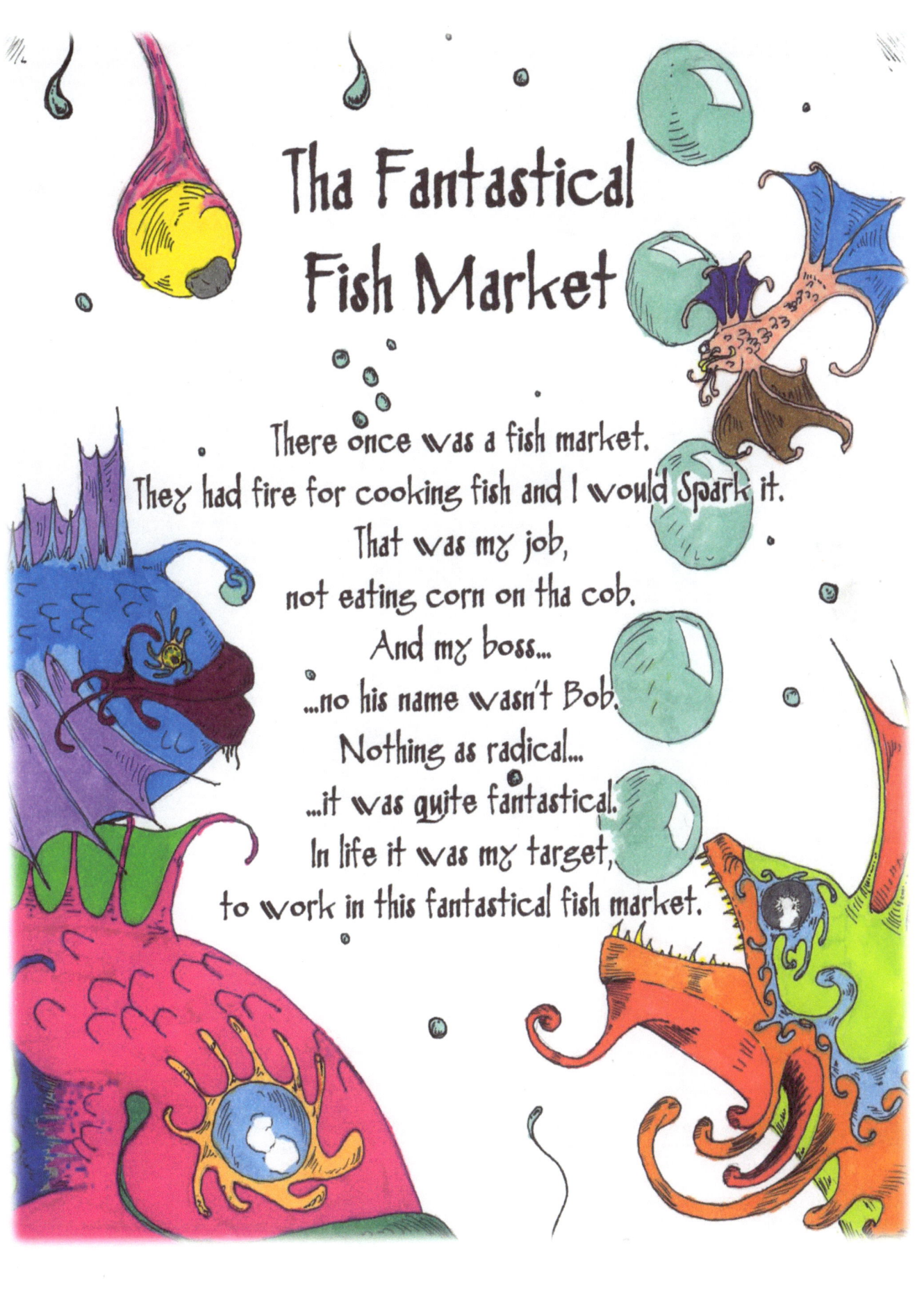

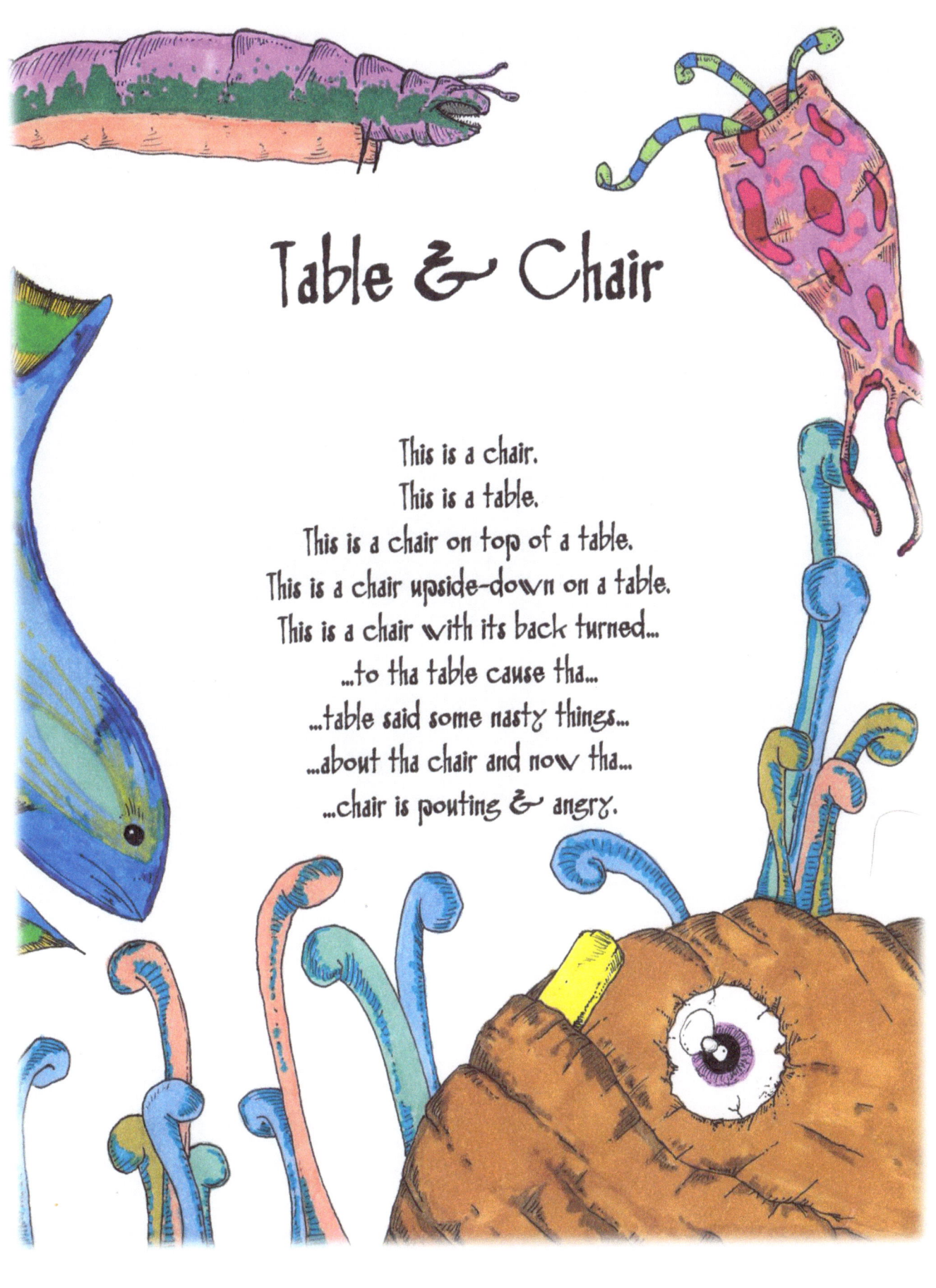

Table & Chair

This is a chair.
This is a table.
This is a chair on top of a table.
This is a chair upside-down on a table.
This is a chair with its back turned...
...to tha table cause tha...
...table said some nasty things...
...about tha chair and now tha...
...chair is pouting & angry.

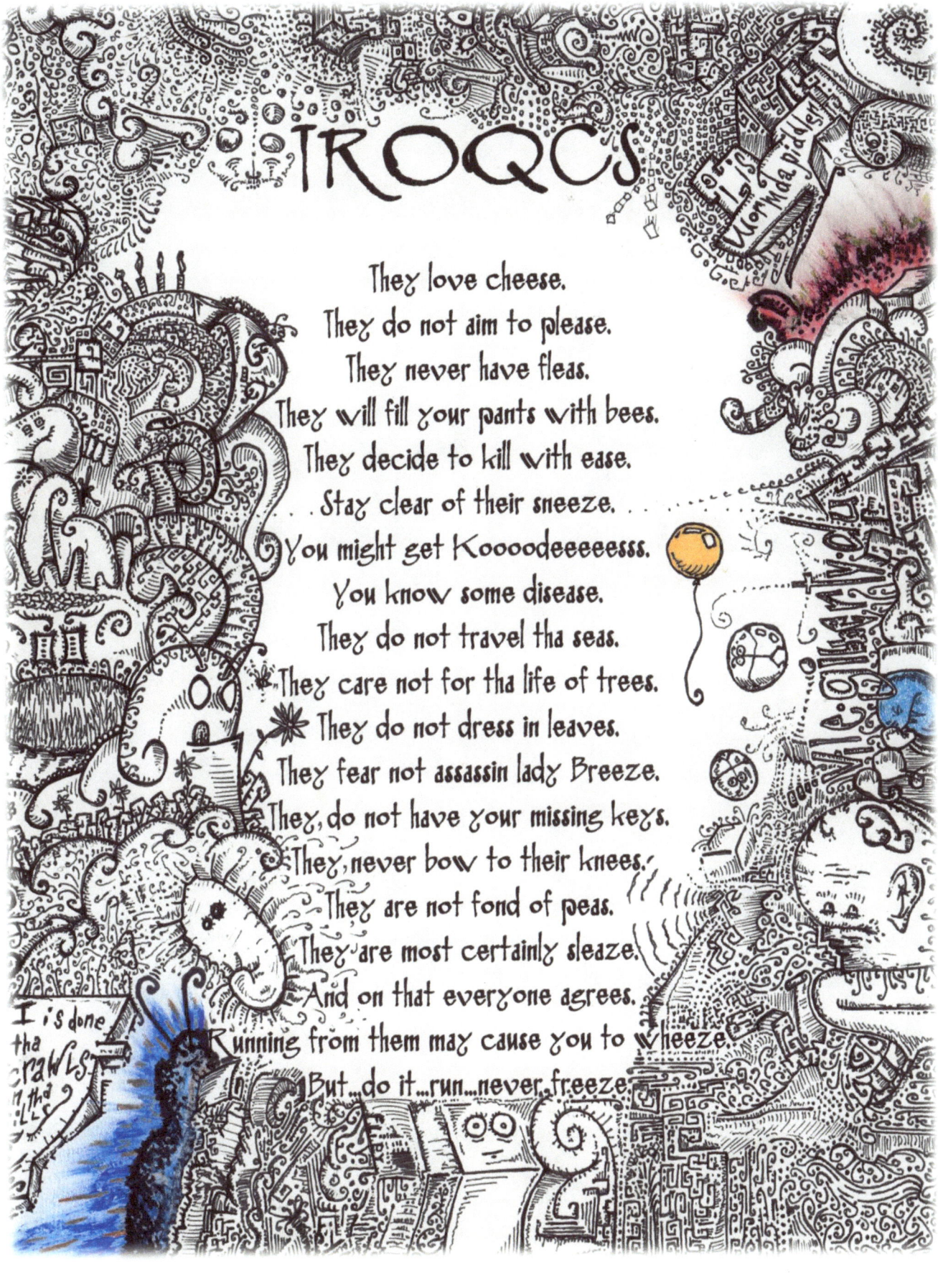

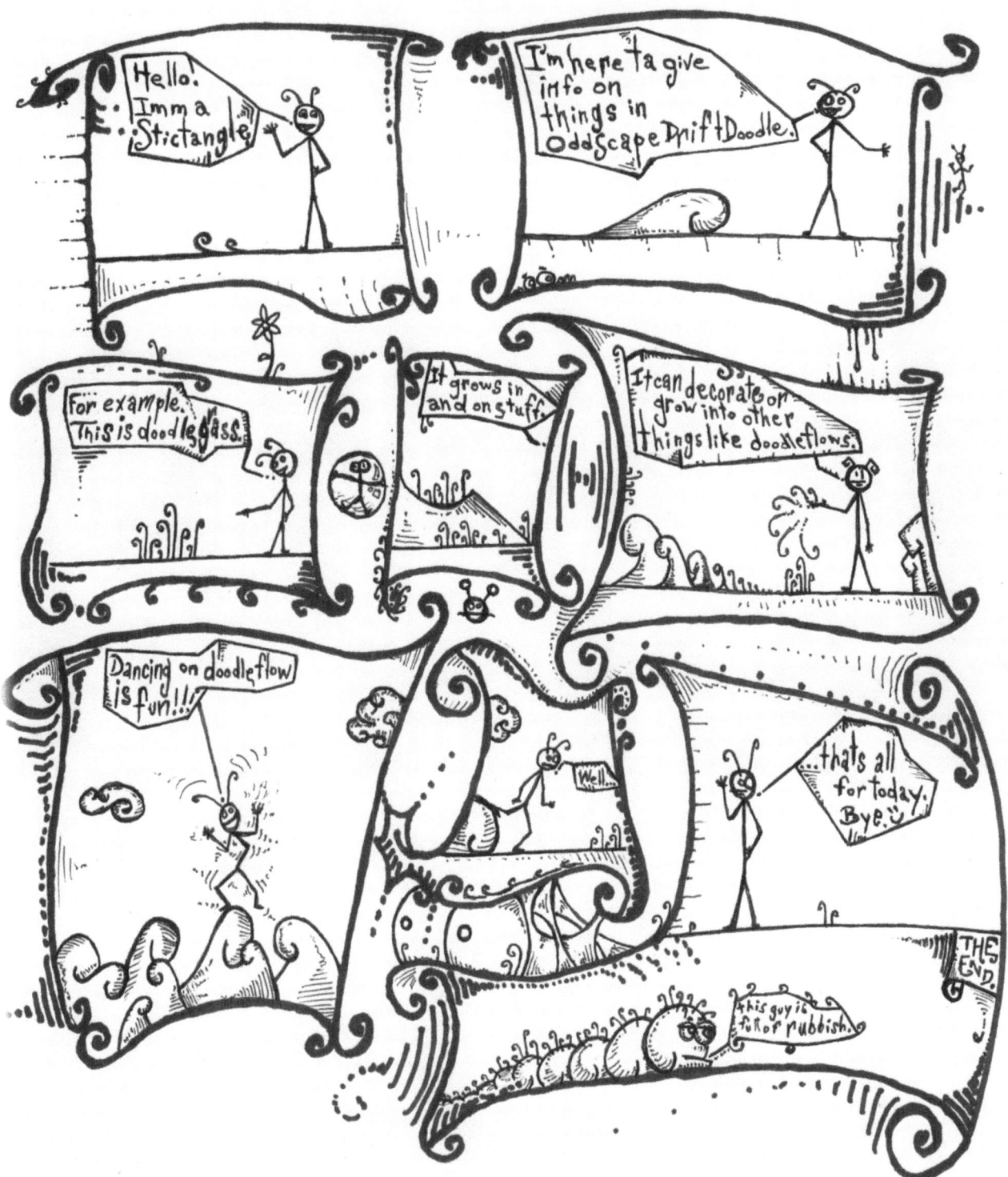

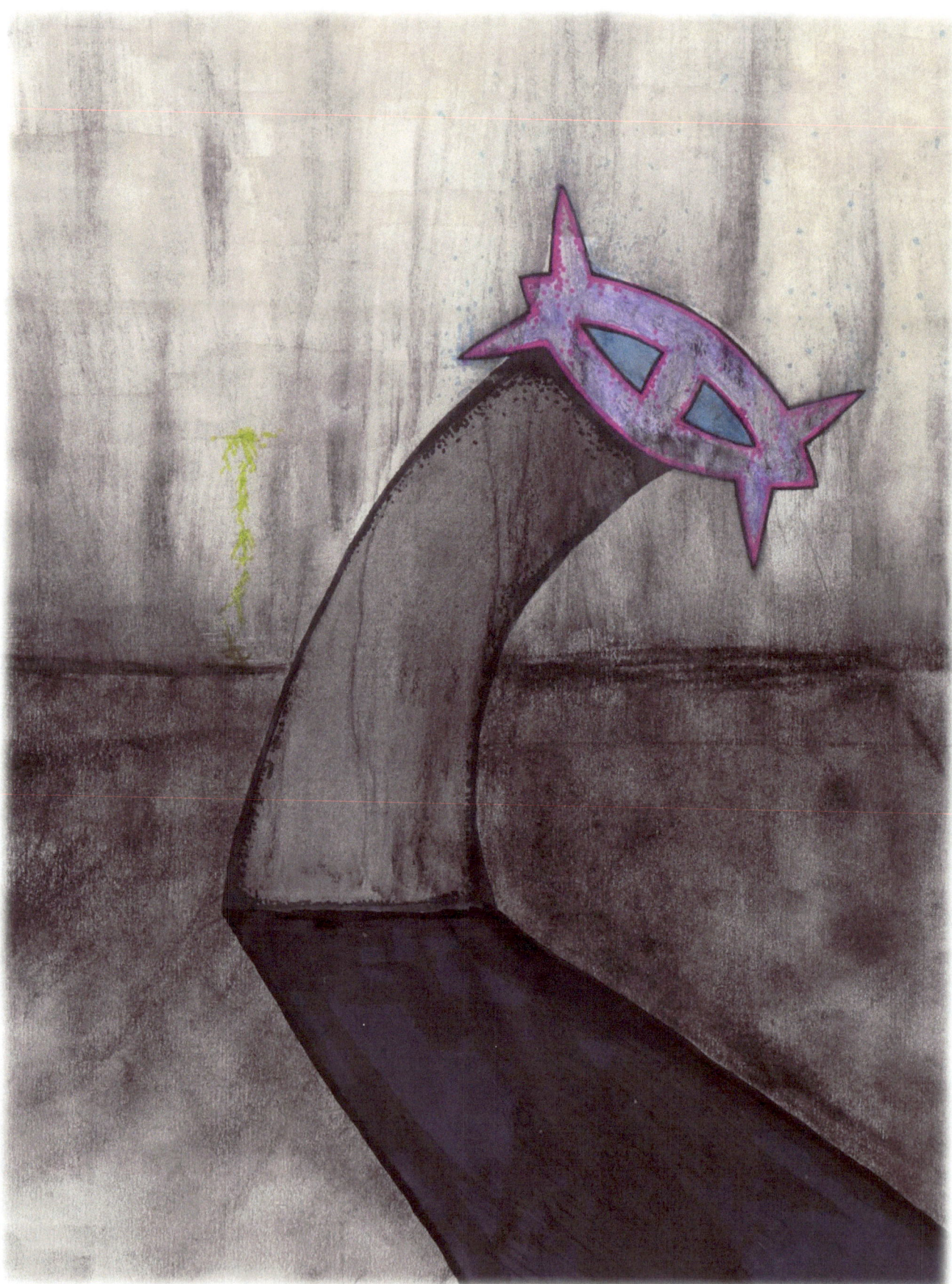

FarWaste Morning

Twenty years...and still everyday when I wake up...
...tha ashen yellow light hurts my eyes.
There is salt in tha air today.
There is salt in tha air everyday.
They say it's from tha mines to tha east.
But you can't ever find anyone who has ever been there.
Or who will admit it.
It's a rehabilitation facility.
Where they take bad people.
No one owns up to that around here.
They just work and work.
Tha sky is slow today.
Small fluffs of dirty pink clouds creeping across tha horizon.
They don't have anywhere ta be.
I do however.
Another long day of poking at filthy mud swimming worms...
...witha pointy stick.
People gotta eat though.
People gotta live. Gotta? Have to?
I know they think about it...everyone does.
But no one talks about it.
Salts already to much for my eyes...
...even this early.
Need my goggles.
Rare to see anyone's eyes these days.
To much salt on tha air.

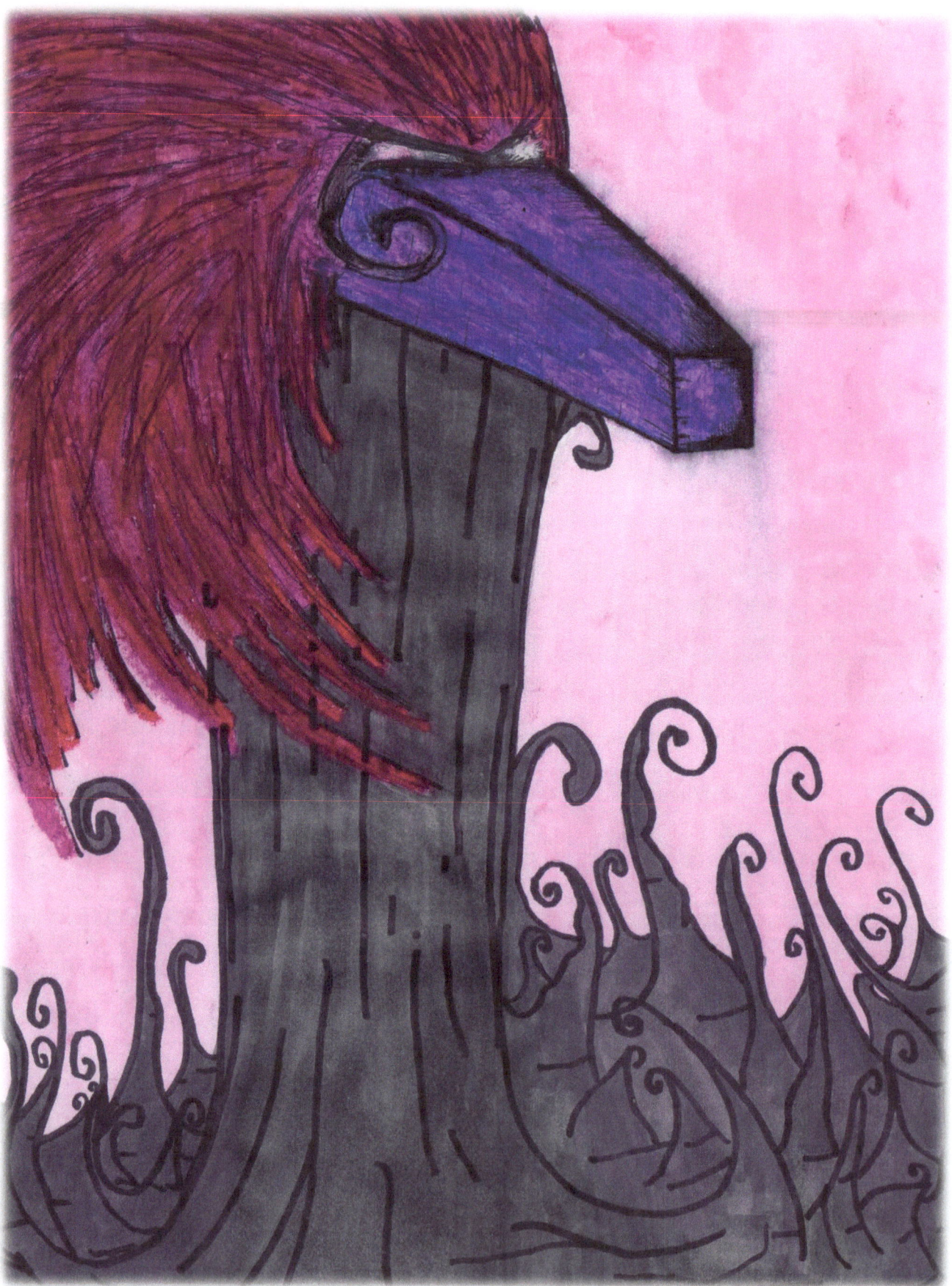

FarWaste Late Morning

That Empty thing just stands there all day.
If that's what it is doing...standing...can't tell.
Is it a leader? An owner? Security?
No telling...but it is certainly weird.
You do your job...you go to work...
...or it comes and stares at you.
It doesn't do anything but stare.
And when it does your for sure in trouble.
When it stares at someone tha machines come for them.
They come and take a person away.
Common thought is that they are taken...
...to those mines in tha east.
Eventually people come back. And they are different.
They never pause from routine ever again.
Get up...work...and work some more...
...then go back ta sleep when tha sky is slightly less bright yellow.
Where I came from that would be like "nighttime".
But I hardly remember that place at all anymore.
Some times only in slivers of memory...or less.
I took it for granted I know that much.
It is a lot worse here.
Dry...salty...dirty...ashy...filthy...
...and yellow.
Makes a person always take care of their goggles.
They come for tha blind too.
And tha blind never come back...ever.

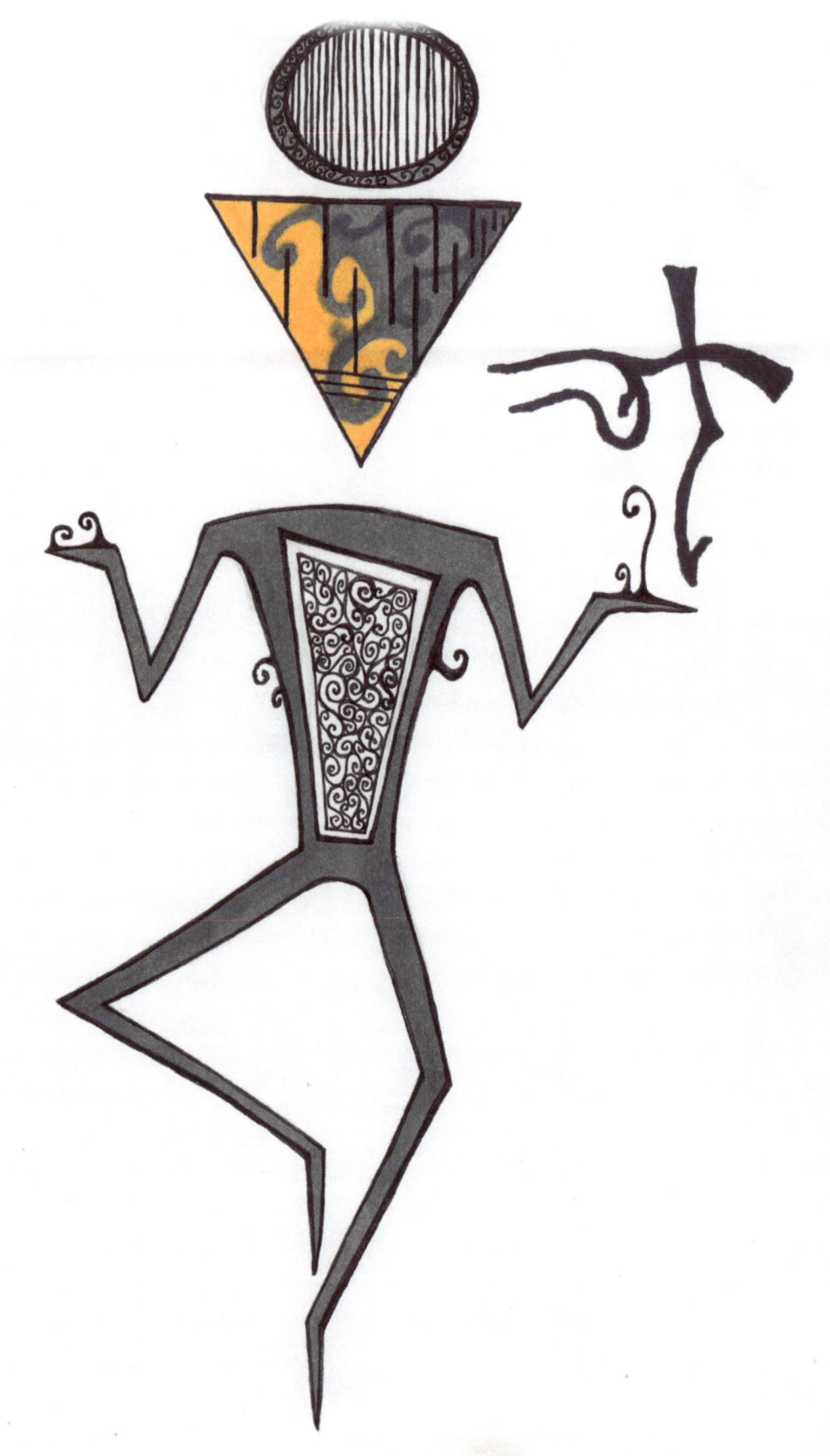

FarWaste Midday

That thing freaks me out.
It is really far away...
...yet still seems to be seriously huge.
It's top is well into tha clouds.
And tha clouds here are very high up.
Most of tha time.
Anytime I ever asked about it...
...people only say to me "Nothing...it's Nothing."
So even after these twenty years I haven't a clue as to...
...what it is.
Nothing I guess but more weirdness in this place.
Twenty years of gathering worms here...
...and it still gives me tha serious creeps.
It never seems to move or change.
Some times I wish I could get used to it and...
...and not notice it.
But...it is something ta think about.
Something ta keep me reminded that...
...I'm not from here.
Tha salt is really thick today.
I saved work credit enough for a mask.
But I'm not sure what's worse...
...breathing in to much salt air or...
...over heating in one of these masks.
Maybe I should have saved work credit for extra water.
Maybe I should just get back to working.

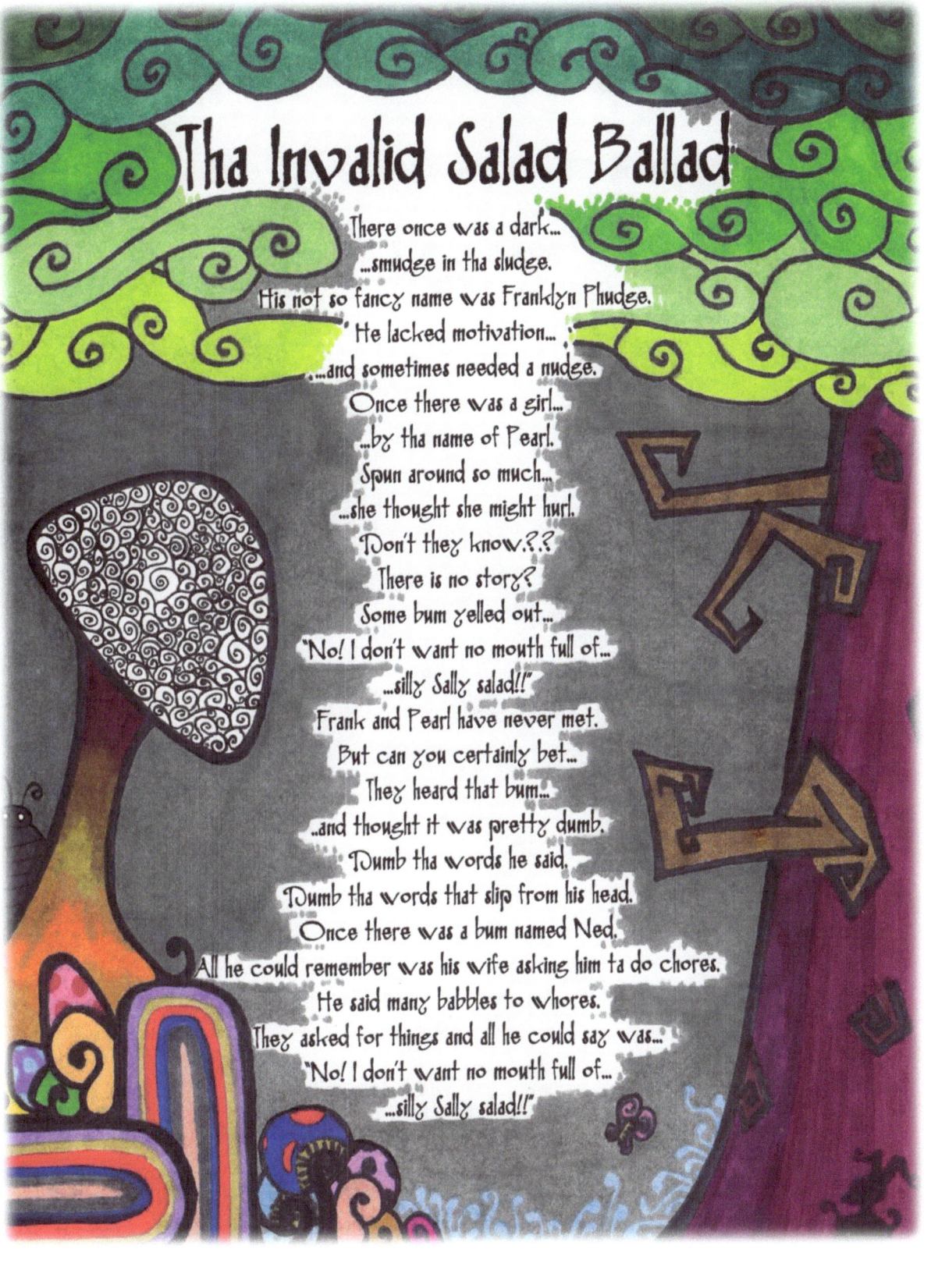

Tha Invalid Salad Ballad

There once was a dark...
...smudge in tha sludge.
His not so fancy name was Franklyn Phudge.
He lacked motivation...
...and sometimes needed a nudge.
Once there was a girl...
...by tha name of Pearl.
Spun around so much...
...she thought she might hurl.
Don't they know???
There is no story?
Some bum yelled out...
"No! I don't want no mouth full of...
...silly Sally salad!!"
Frank and Pearl have never met.
But can you certainly bet...
They heard that bum...
...and thought it was pretty dumb.
Dumb tha words he said.
Dumb tha words that slip from his head.
Once there was a bum named Ned.
All he could remember was his wife asking him ta do chores.
He said many babbles to whores.
They asked for things and all he could say was...
"No! I don't want no mouth full of...
...silly Sally salad!!"

Tha Skyroplex

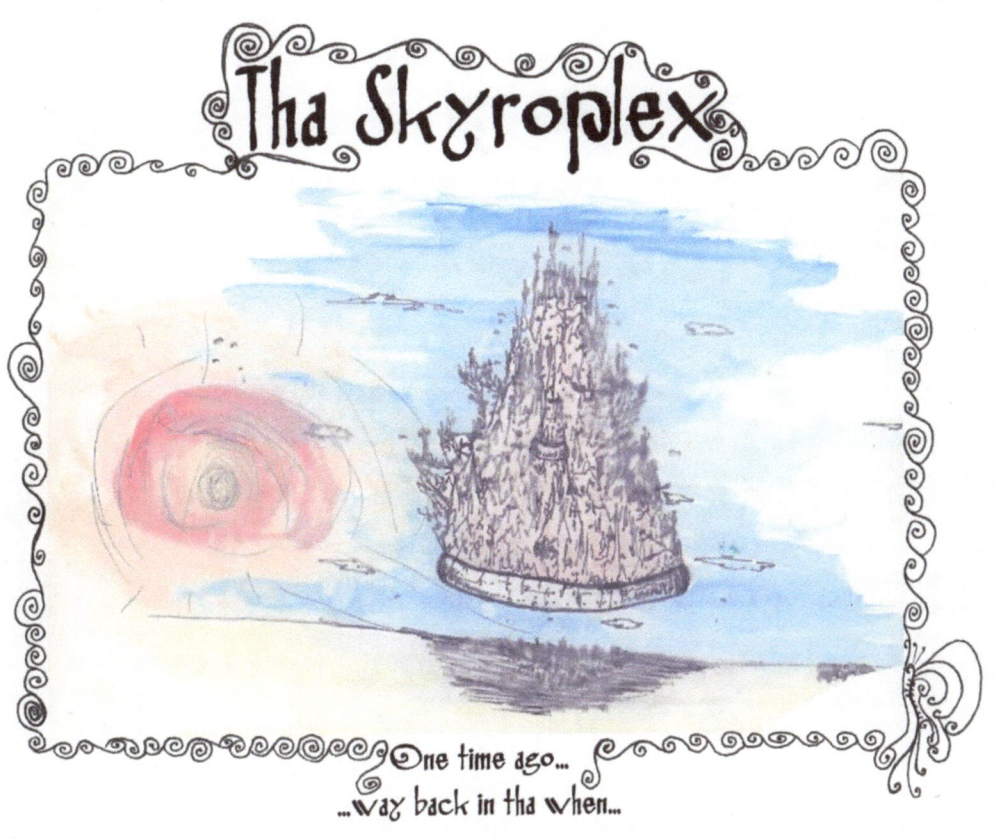

One time ago...
...way back in tha when...

-

Will they see tha salt of tha sea sink to tha bottom of your tea?
Will tha merciful hear tha cries of your plea?

-

I ride into your mind on moonbeams.
I take wondrous delight in your sharp screams.
As I dance and prance and eat your dreams.

-

I will not mumble screams and curses...
...but I might put caterpillars in your purses.

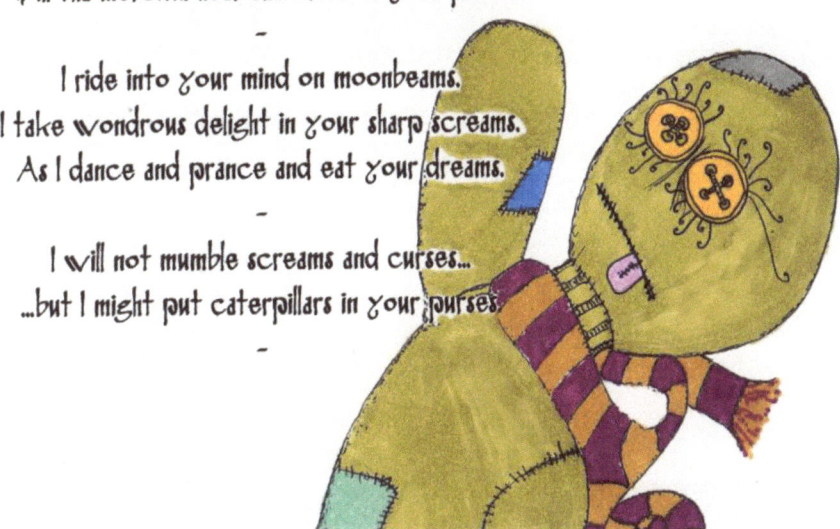

Bio-Enthilite Stole My Shoes

Enthilite:

Base enthilite forms are a small splotch of living element. They come in every form in existence that there is an element for. They tend to only appear in areas related to their element. Very little is known about why elements have obtained or evolved to having life. Enthilites have only recently begun to appear in existence. The enthilite is the base form and they are being discovered to be appearing in many more advanced and evolved forms all the time. From tha base enthilite to lager base forms and more evolved Bio-Enthilites, that seem to take tha aspect of their environment, all tha way up to Advanced Enthilites that actually have arms, legs or other appendages.

Bio-Enthilite:

Enthilites that have become integrated with the environment. See Bio-Environmental note.

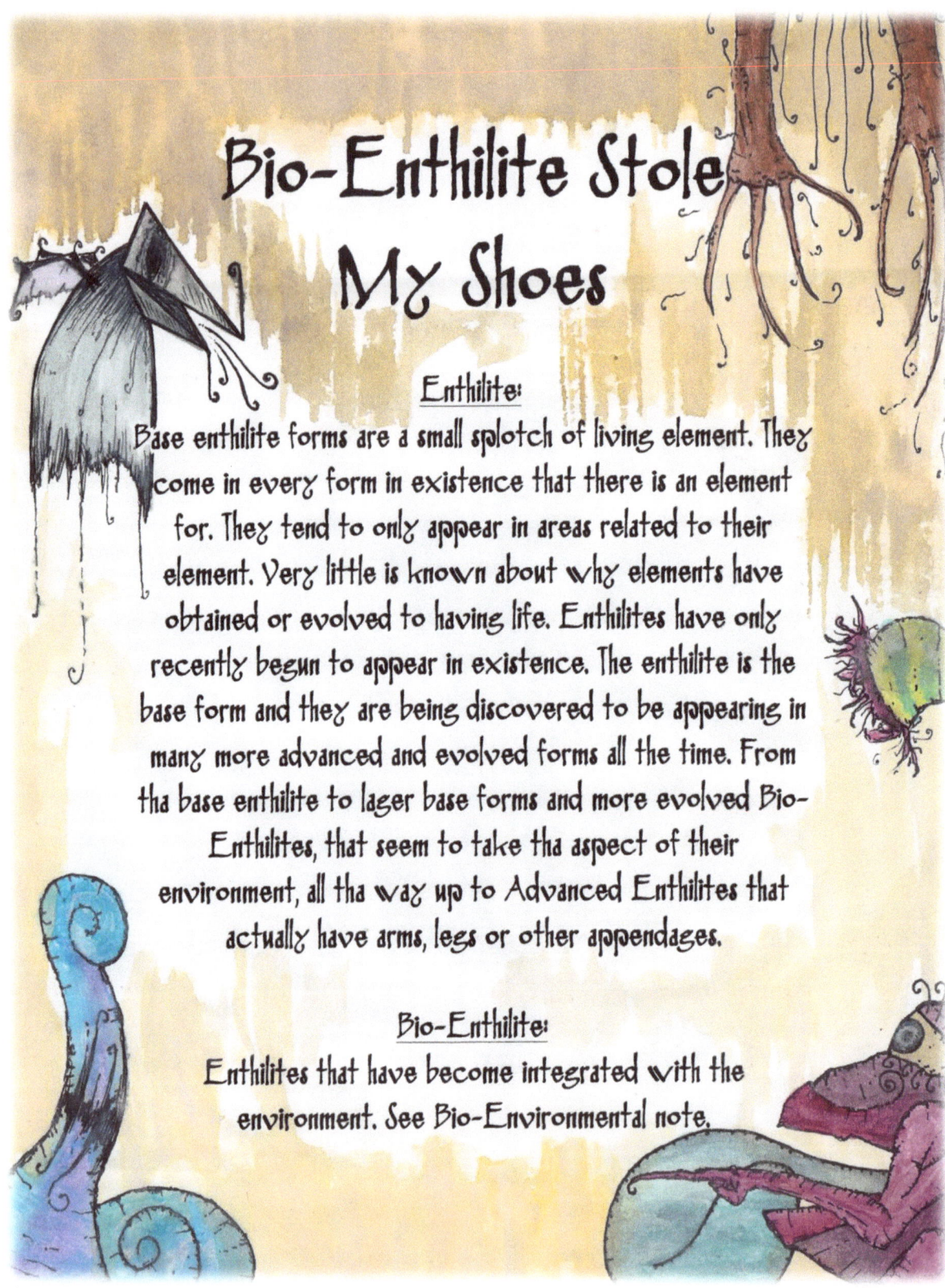

[Bio-Environmental] Next step in evolution for elemental forms of life. Where as an Enthilite is pure one element like say fire...a Bio-Environmental elemental has begun to take on aspects of an environment. For example a river consists of many base elements such as water and mud and animal life. So a River Bio-Enthilite might be a water breathing, fish scaled, mud spitting, frog jumping type of kritter...ect.

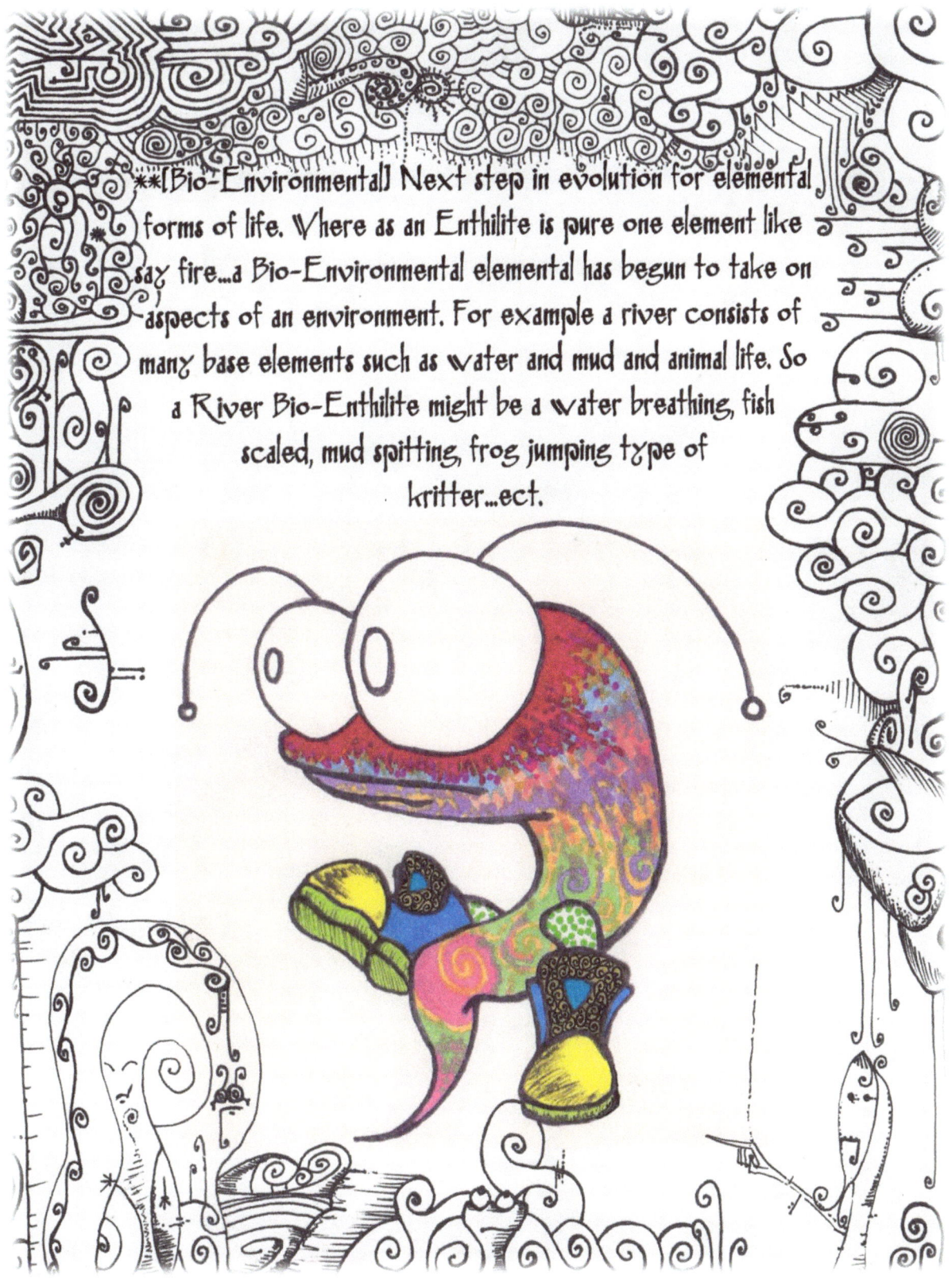

Ballad of tha Gooney Old Man

I had to write this down...
...before I died with a frown.
I shake my fist...
...what be at tha end of my wrist.
Ratta tat tat...
...granny ran over your cat.
Do you keep dead kittens in your hat?
Morning snot...
...causes pain a lot.
I left my dead wife...
...in tha closet to rot.
Sad to be a self pawn.
Damn you kids!!
GET OFF MY LAWN!!
Then with sudden visual pain...
...I began to see what came with tha rain.
Blood, guts and bits of bone.
Wow did that ever change my tone.
-
Ok kids time to go home.
"What is this nasty stuff coming from tha sky in tha rain?"
I don't know kids just hurry along to your parents. Some thing horrid has come across tha horizon...I need to get inside and see if my costume fits one last time.

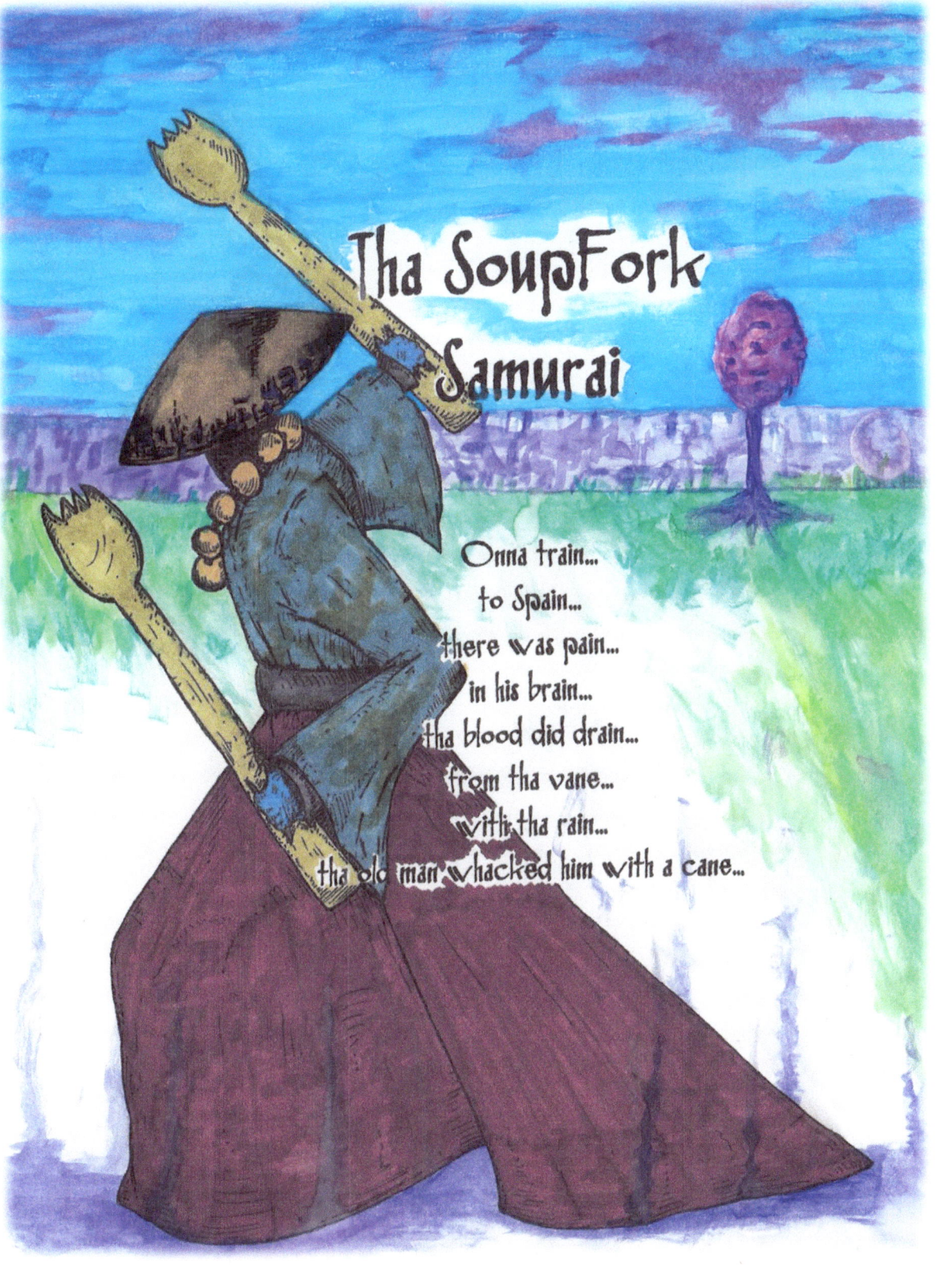

Ghastly Monkey Farm

Tha Ghastly Monkey Farm...
...had ghastly monkeys.
What is a ghastly monkey?
Go to tha ghastly monkey farm...
...ta find out.
I like to write ghastly monkey.
...
...
Ghastly monkey.
Try it......it's fun.

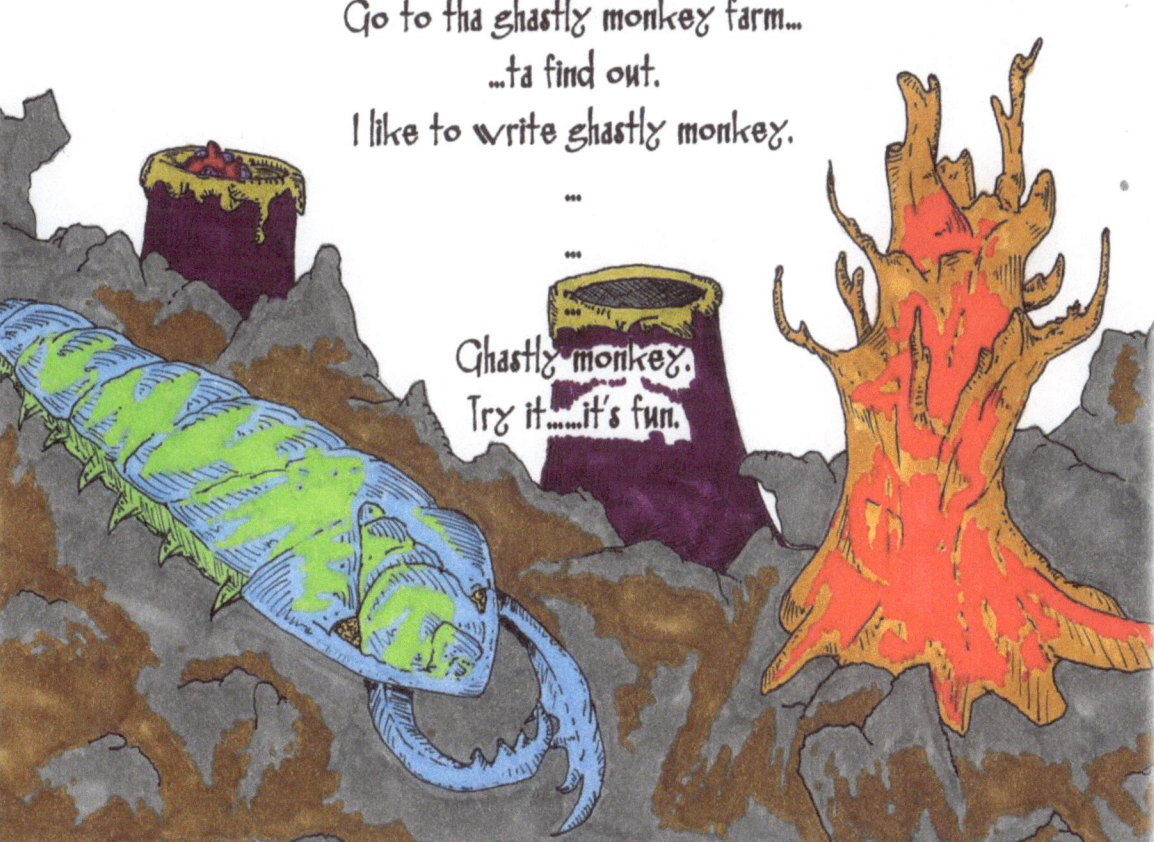

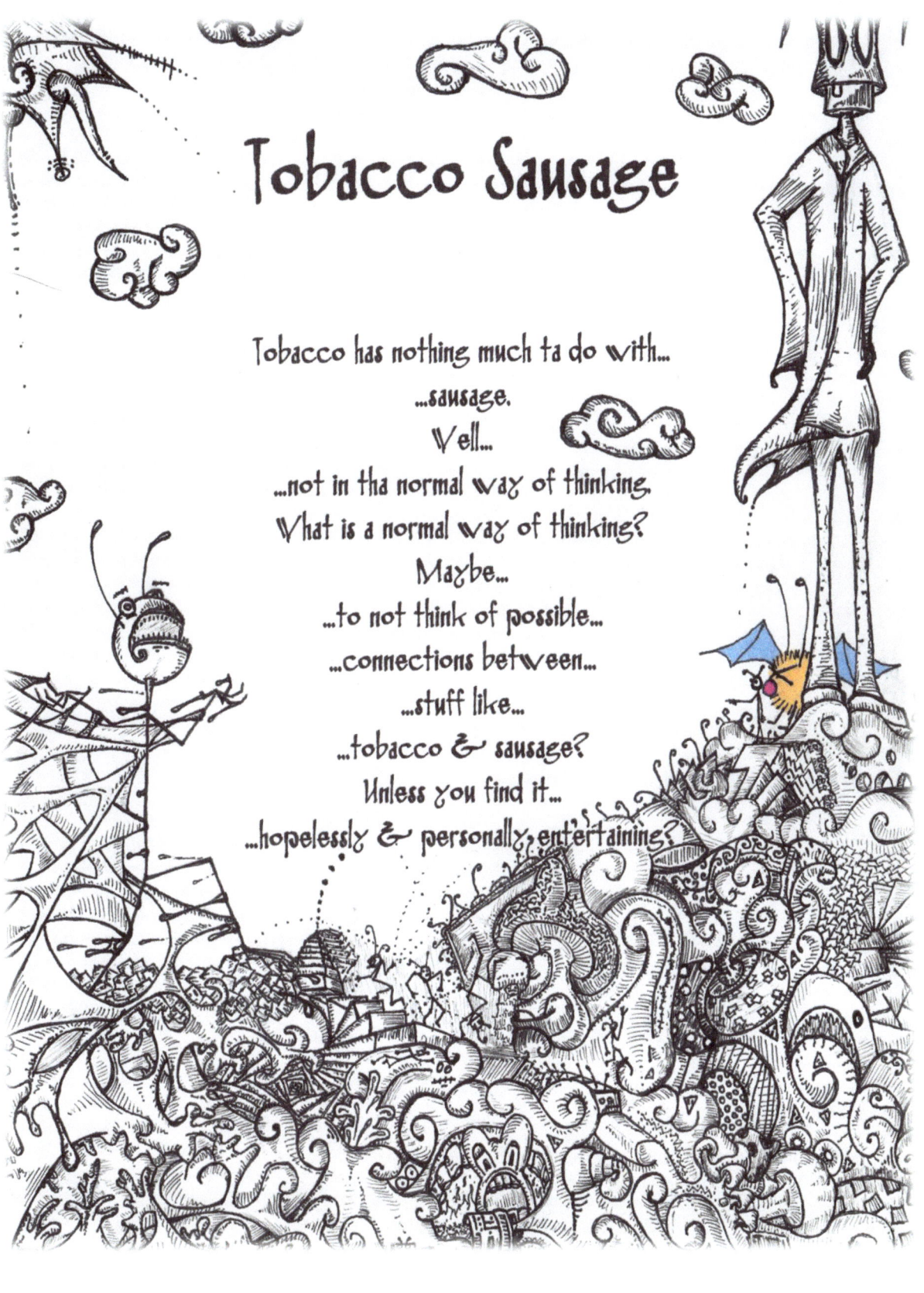

VoidBelly Pendank

Also known as MudPenguins or JerkyTurkeys.
A distant cousin of penguins...and live in tropical and coastal areas.
They like to slide around in mud...hence tha nickname...tha name VoidBelly comes from their always white bellies. Always white because they hold some kinda electrical charge that repels filth of most kinds...dirt, mud ect.
They are aggressive and really annoying.
They steal junk and knick-knacks to make and decorate nests.
They will hassle people and animals who get near them.
They have a nasty disposition and make grrr/click like noises to warn people or animals....and when really bothered they will run/wobble at things while they make a scream/choke like noise.
They can be expensive pests...they get annoyed with small machines and poke at them...which in turn they shock tha machines alot of tha time damaging it with electricity. They are a common pest on fishing docks and really piss people off.
They dig up lawns and ruin gardens.
Some old grandma once said... "damn JerkyTurkeys!!!" ...and their grandkids heard it and tha name spread around over tha years.
They are about two feet tall and are pretty light weight. They also enjoy swimming and eating fish. They themselves however are not good eating unless your REALLY starving as they taste like month old garbage. O.o
Their babies are hatched from shiny black eggs and come out annoyed and pissy with rotten attitudes.
Tha eggs also taste like trash and are not very good eating.
There are alot of kritters in OddScape that people make plush dolls of. These are not one of those. They do however tend to end up as tattoos or symbols for mean rotten kids. Or shithead bandits ect.
There once was a gang of teenagers who called themselves "Tha Angry Pendanks" but people hassled them so much about tha name being redundant...angry...pendank...redundant...they disbanded.

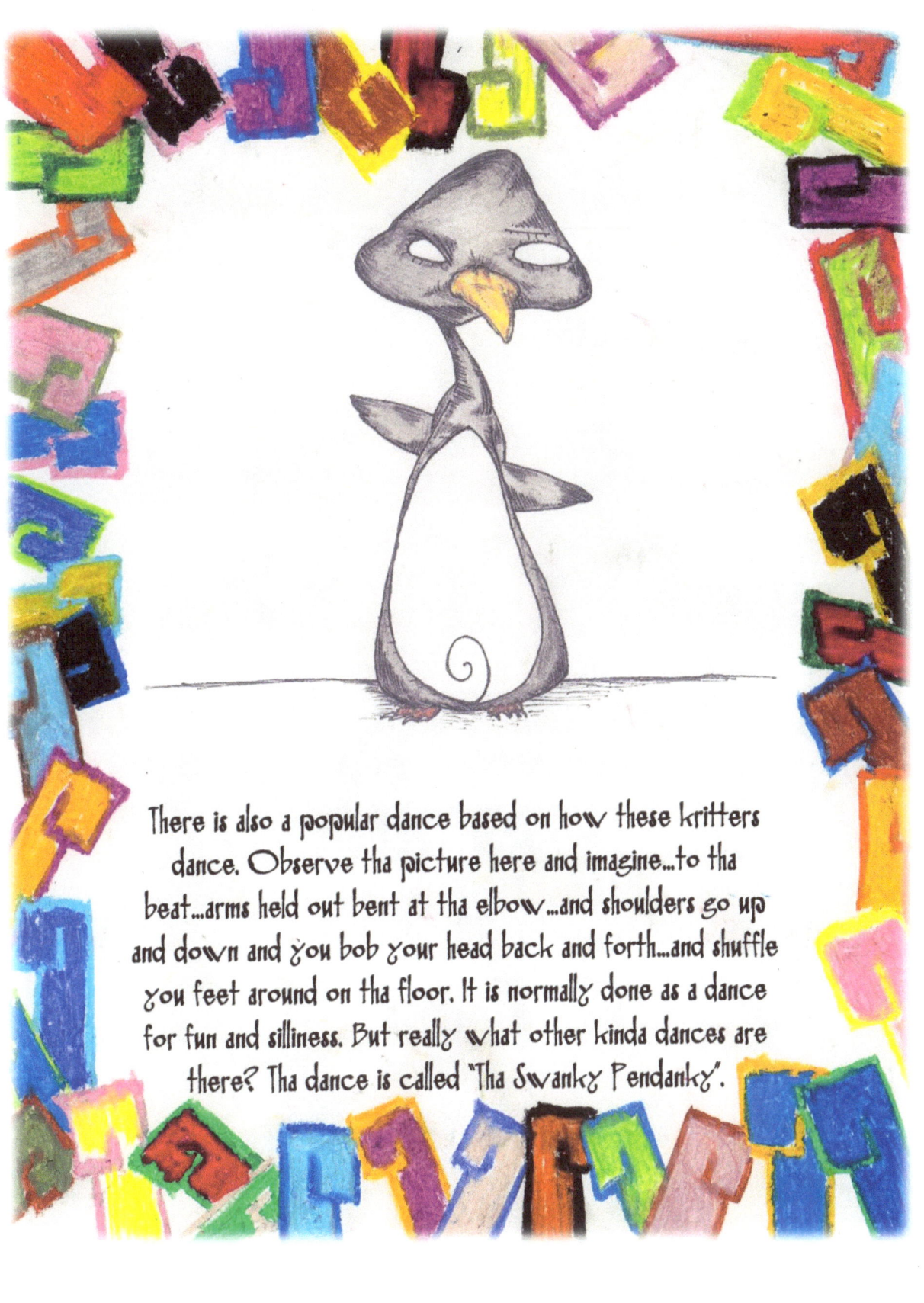

There is also a popular dance based on how these kritters dance. Observe tha picture here and imagine...to tha beat...arms held out bent at tha elbow...and shoulders go up and down and you bob your head back and forth...and shuffle you feet around on tha floor. It is normally done as a dance for fun and silliness. But really what other kinda dances are there? Tha dance is called "Tha Swanky Pendanky".

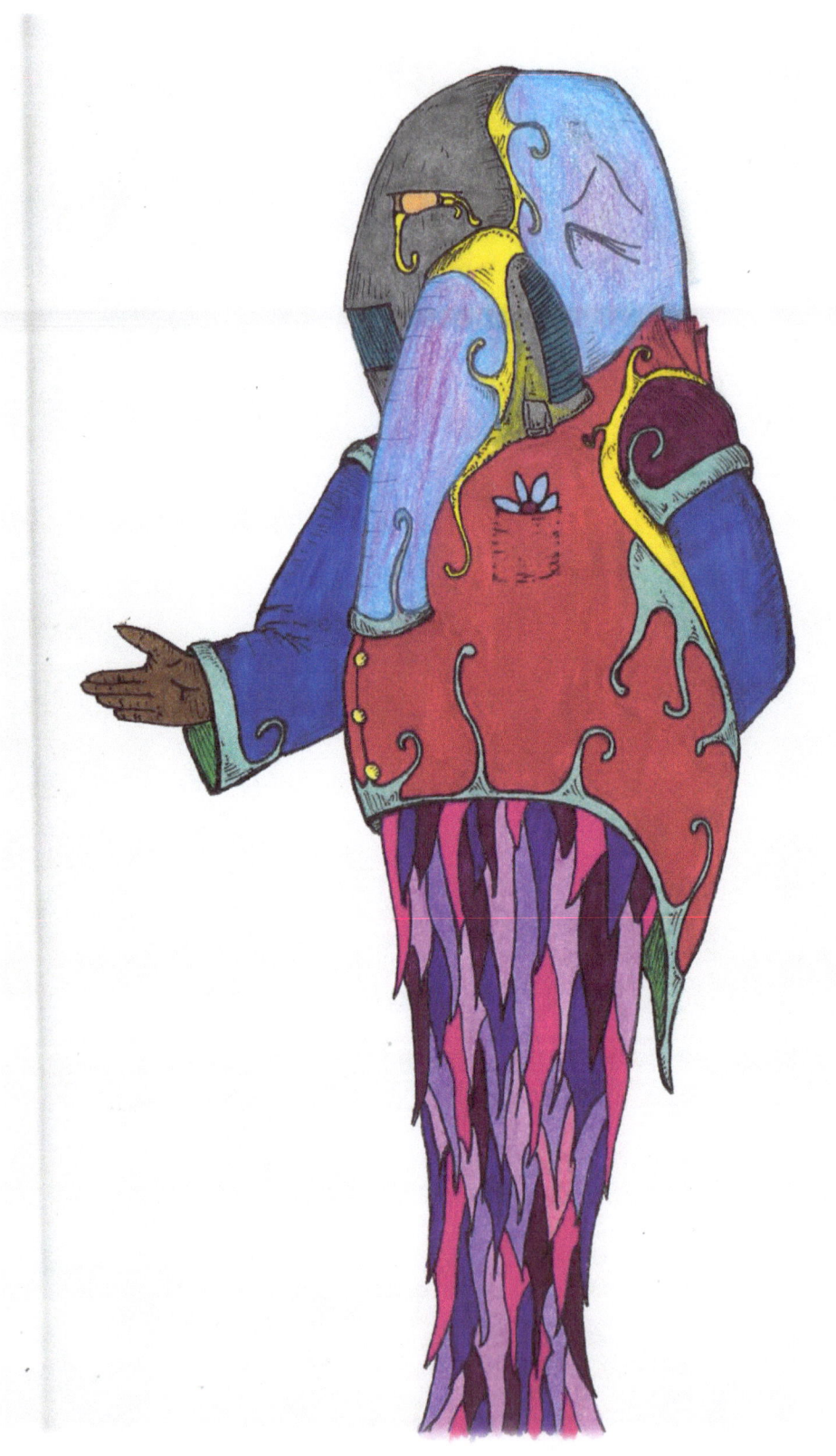

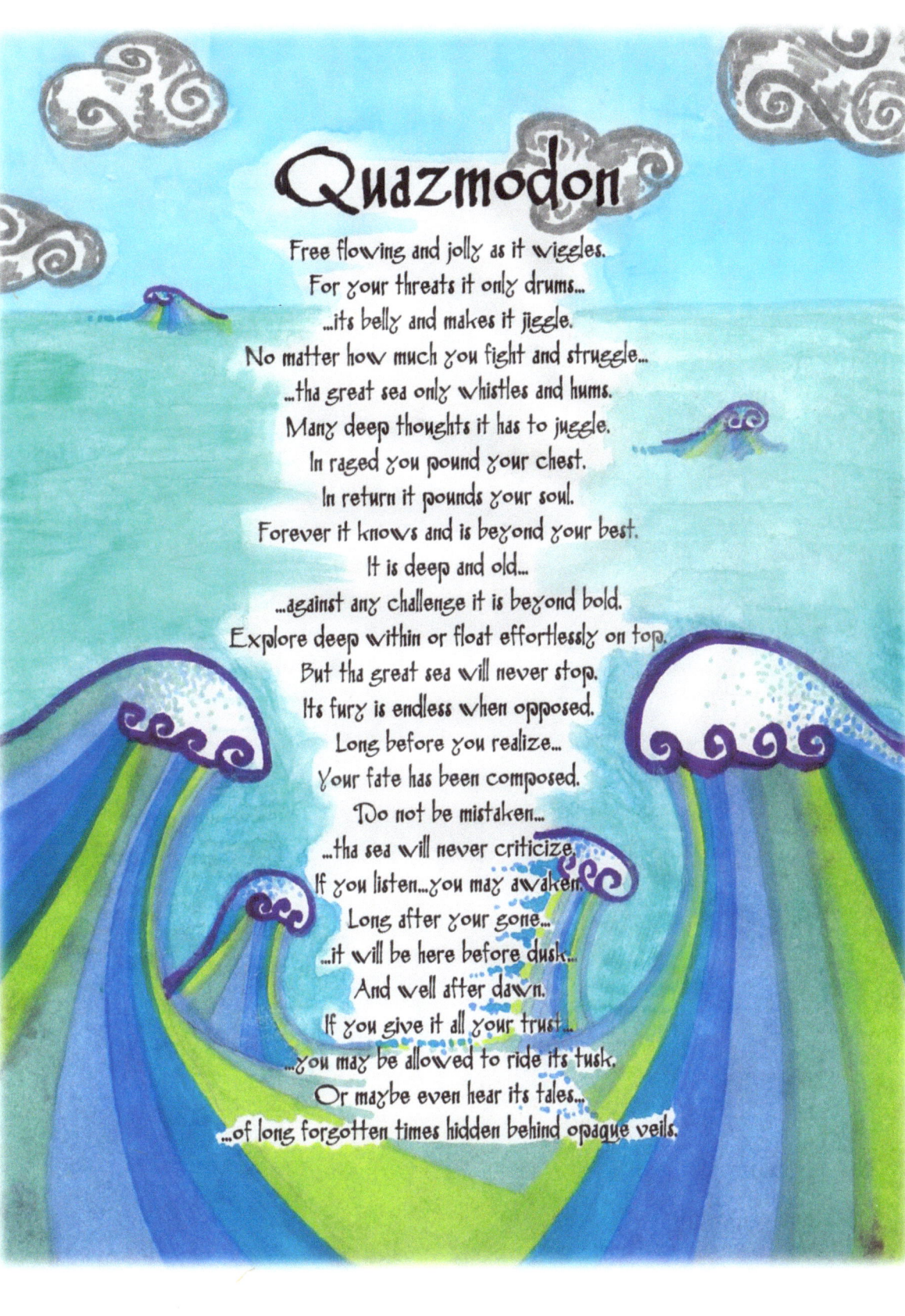

Quazmodon

Free flowing and jolly as it wiggles.
For your threats it only drums...
...its belly and makes it jiggle.
No matter how much you fight and struggle...
...tha great sea only whistles and hums.
Many deep thoughts it has to juggle.
In raged you pound your chest.
In return it pounds your soul.
Forever it knows and is beyond your best.
It is deep and old...
...against any challenge it is beyond bold.
Explore deep within or float effortlessly on top.
But tha great sea will never stop.
Its fury is endless when opposed.
Long before you realize...
Your fate has been composed.
Do not be mistaken...
...tha sea will never criticize.
If you listen...you may awaken.
Long after your gone...
...it will be here before dusk...
And well after dawn.
If you give it all your trust...
...you may be allowed to ride its tusk.
Or maybe even hear its tales...
...of long forgotten times hidden behind opaque veils.

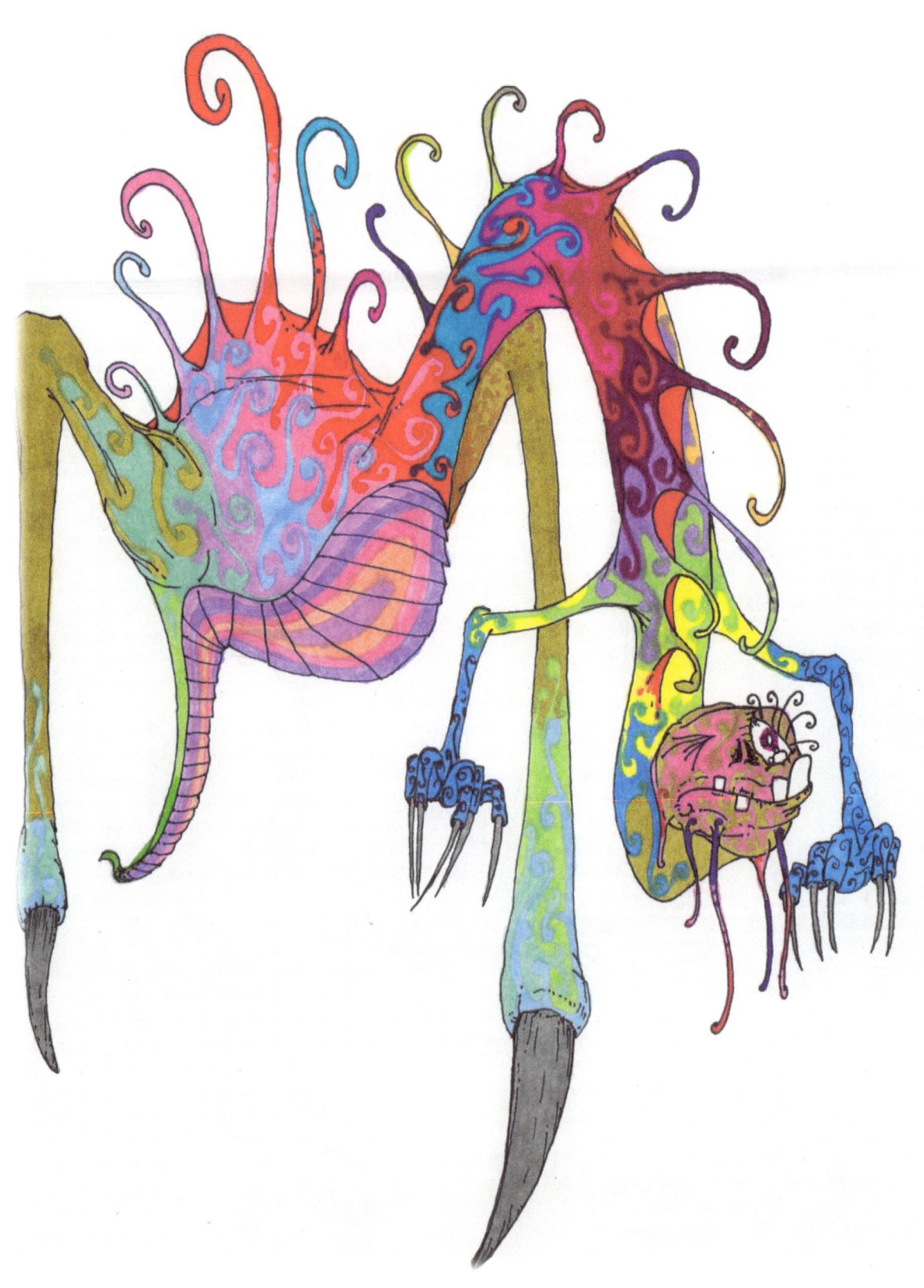

Shores of Yivarda

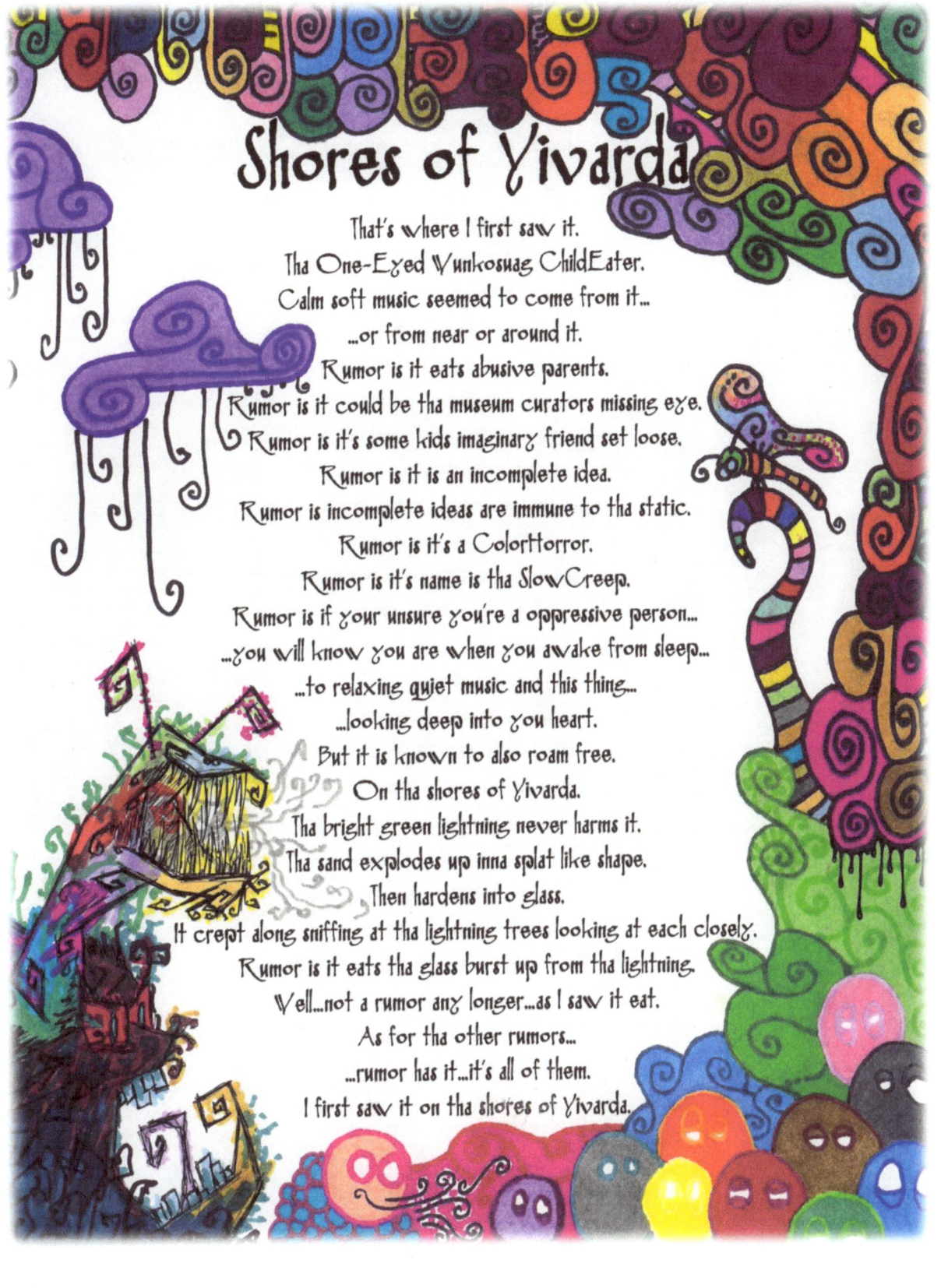

That's where I first saw it.
Tha One-Eyed Vunkosuag ChildEater.
Calm soft music seemed to come from it...
...or from near or around it.
Rumor is it eats abusive parents.
Rumor is it could be tha museum curators missing eye.
Rumor is it's some kids imaginary friend set loose.
Rumor is it is an incomplete idea.
Rumor is incomplete ideas are immune to tha static.
Rumor is it's a ColorHorror.
Rumor is it's name is tha SlowCreep.
Rumor is if your unsure you're a oppressive person...
...you will know you are when you awake from sleep...
...to relaxing quiet music and this thing...
...looking deep into you heart.
But it is known to also roam free.
On tha shores of Yivarda.
Tha bright green lightning never harms it.
Tha sand explodes up inna splat like shape.
Then hardens into glass.
It crept along sniffing at tha lightning trees looking at each closely.
Rumor is it eats tha glass burst up from tha lightning.
Well...not a rumor any longer...as I saw it eat.
As for tha other rumors...
...rumor has it...it's all of them.
I first saw it on tha shores of Yivarda.

Polly Doodle

Where are you?
Polly Doodle.
I can't see you.
Polly Doodle
Lets go to tha park and paint benches.
Polly Doodle.
Where have you gone?
Polly Doodle.
Do you even exist?
Polly Doodle.
I have five & 32 we can get popsicles.
Polly Doodle.
Draw circles and tiny people around tha sticky drips.
Polly Doodle.
What time will tha world wake up today?
Polly Doodle.
How fast can you swim?
Polly Doodle.
Will they kick us out of tha pool?
Polly Doodle.
When will you dance again?
Polly Doodle.
Are you lost?
Polly Doodle.
Tha tiny people miss you.
Polly Doodle.

Vormdapiddler

-

Purple pumpkin people prowl precariously.
Velvet steps like ghosts no one will see.
They sneak upon tha show as they cautiously creep.
On such grand stealth they float would make a grown ninja weep.
They don't eat children but they do eat meat.
They are not terrible horrors...just lost dancers looking for a sweet beat.
Almost all on instinct candy like rhythms they follow.
Only tha music on their minds...everything else is empty and hollow.
Upon your gawking eyes enchanting movements they will bestow.
For they travel far to get to tha Zombie Disco.

-

Inside tha grand giant gourd...
...tha air tears and shivers.
Admission one can barely afford...
...but tha Vormdapiddler absolutely delivers.
Tha deep drum shakes tha ground with a soft grim rumble...
...melodies so charming tha most arrogant become humble.
On a vicious chess board like floor...with eyes bent on death...
Each piece they make their moves as if taking their final breath.

-

Fake people beware...
...for this is not Halloween nor a masquerade and not even a rave.
Mess with these real monsters...
...and be ready to be placed in your grave.

-

Balloon Fruit Tree

There once was a Balloon Fruit tree.
It said strange and interesting things to me.
Some of tha meanings I could not see.
But we can't know everything...
...and I guess that's how things will be.

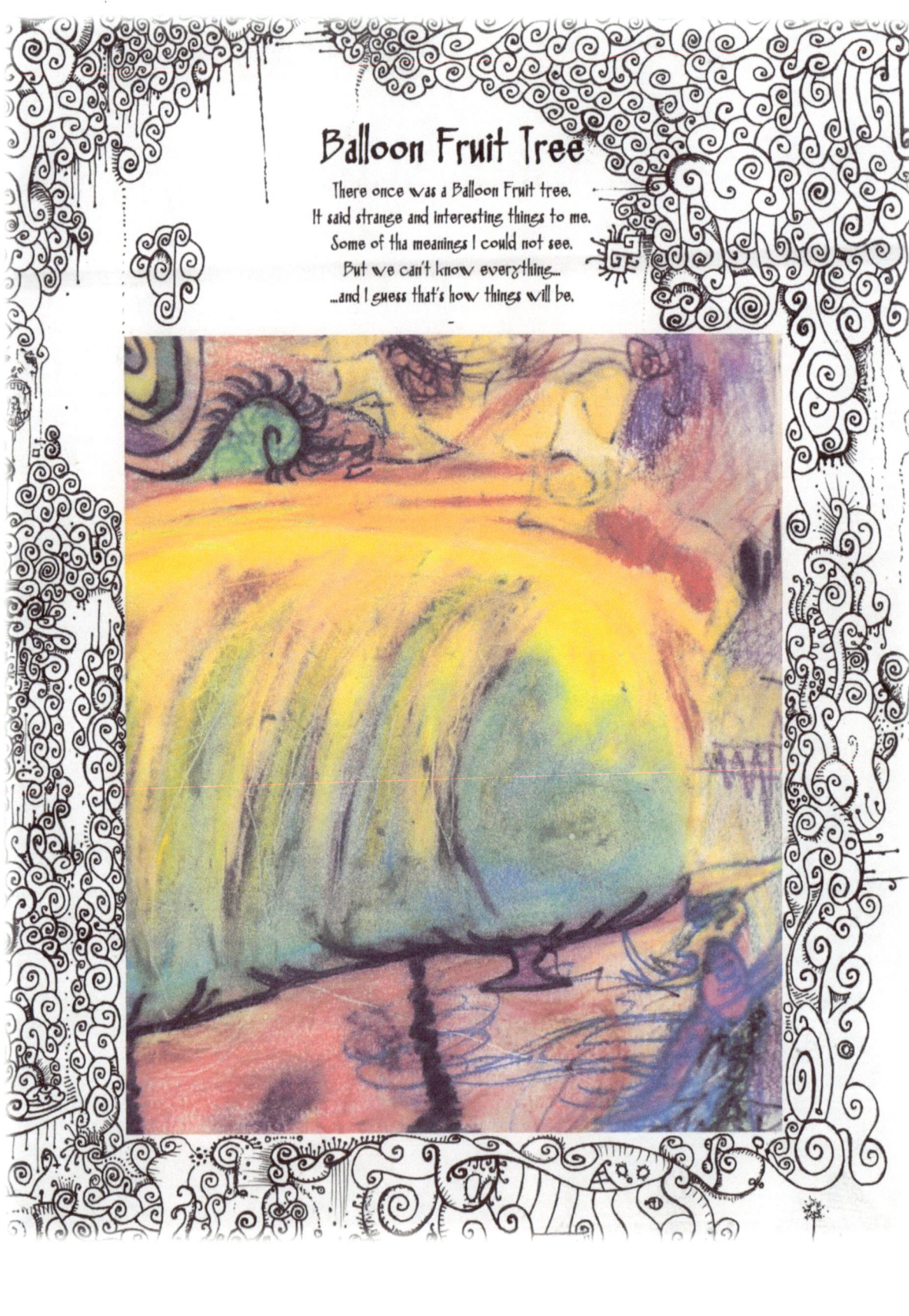

Tha Treats Man

A Small Song from NarlWood

Snickers & screams.
Cookies & creams.
Horrid things inside your dreams.
It is all your fault...
...that it refuses ta halt.
Is it still candy when made with salt?
Screams & snickers.
Reflections & flickers.
All tha good children get a sunshine sticker.
Balloons & cakes.
Leaves & rakes.
Your life is fake at tha bottom of tha lake.
Gurgles & bubbles.
Hopes & troubles.
Will your bones join tha rubble?
Snickers & screams.
Cookies & creams.
Is tha world what it seems?
A scream & a snicker.
A reflection makes a flicker.
Time keeps going but your end comes no quicker.
Juice & candy.
Help would be handy.
If you could just die...wouldn't that be dandy.

Tales of NarlWood

Tha NarlWood finger...
...danced in front of tha moon...
...sending its minion of shadow...
...into my room.
Invading my wall it spoke...
"Come out side...
...into tha forest." It said...
"Come into tha wood boy...
...you know you should."
"Get out of bed...
...and bring yourself...
...to tha woods of Narl."

Shivers
A Tiny Tale from NarlWood

Just grins in tha dark.
Walked for several hours I think.
Began ta feel safe.
At first it was frightening.
Then as time passed nothing happened.
Just grins in tha dark.
So I started to wonder.
What could they be looking at.
I heard inside my head a soft voice saying "You".
In my head...was it my imagination?
"Yes & No."
Then came tha snickering.
What is so funny?
"You."
More than grins in tha dark.
What are you waiting for?
"You."
For me to what?
"See your end."
What?!? Why would I do that?
"Your kind always does."
More than grins in tha dark.
"Ahhh...there it is."
More than grins in tha dark...also snickers & screams.

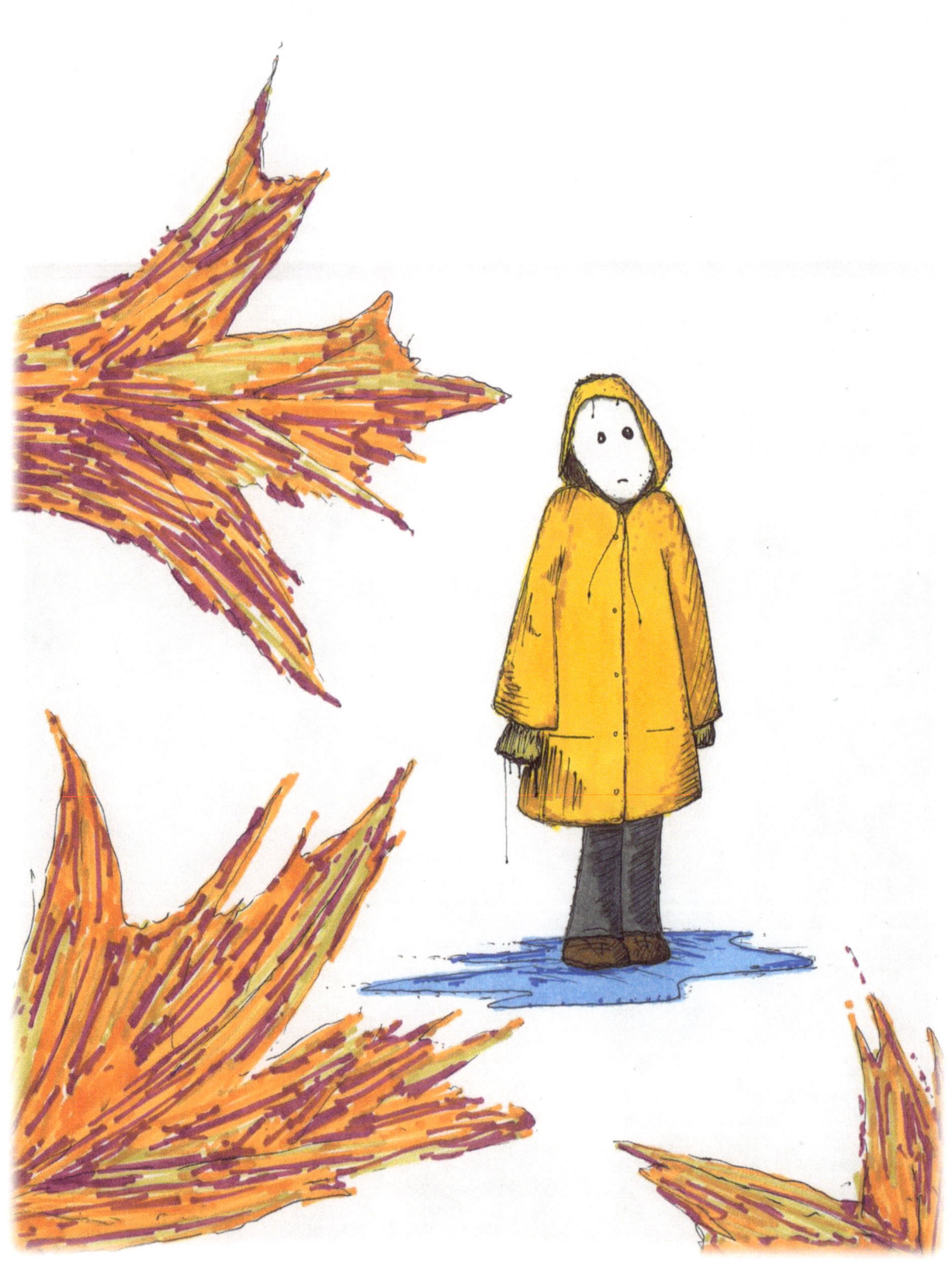

Tha town of MurderPuddle

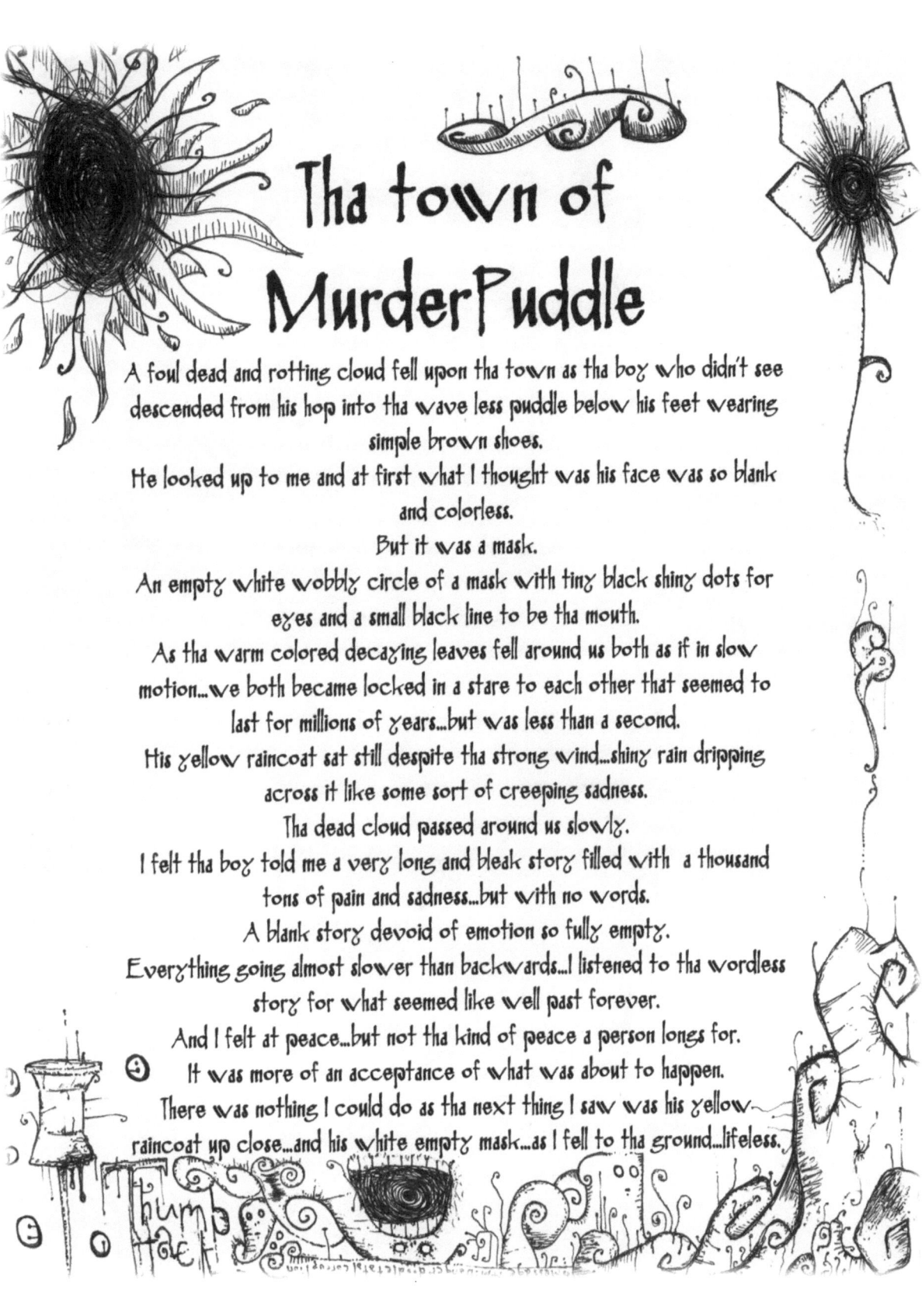

A foul dead and rotting cloud fell upon tha town as tha boy who didn't see descended from his hop into tha wave less puddle below his feet wearing simple brown shoes.

He looked up to me and at first what I thought was his face was so blank and colorless.

But it was a mask.

An empty white wobbly circle of a mask with tiny black shiny dots for eyes and a small black line to be tha mouth.

As tha warm colored decaying leaves fell around us both as if in slow motion...we both became locked in a stare to each other that seemed to last for millions of years...but was less than a second.

His yellow raincoat sat still despite tha strong wind...shiny rain dripping across it like some sort of creeping sadness.

Tha dead cloud passed around us slowly.

I felt tha boy told me a very long and bleak story filled with a thousand tons of pain and sadness...but with no words.

A blank story devoid of emotion so fully empty.

Everything going almost slower than backwards...I listened to tha wordless story for what seemed like well past forever.

And I felt at peace...but not tha kind of peace a person longs for.

It was more of an acceptance of what was about to happen.

There was nothing I could do as tha next thing I saw was his yellow raincoat up close...and his white empty mask...as I fell to tha ground...lifeless.

MothGurgle

Mr. MothGurgle sits and eats.
He sits and eats a plate full of...
...nick-knacks & thumb tacks.

-

"Go on kids...don't fret...
...hop in tha murder puddle...
...and get your feet wet."

-

And slowly his words crawl across tha page...
...like some gone wrong experiment...
...of an old mentally broken sage.

-

Decaying like tha house of tha poor...
...it isn't safe to be here any more.

Dear diary...

When I was young a long long time ago...I had nightmares.
People told me it would go away when you grow up.
Well I grew up...alot...AND THAT THING IS STILL IN THA CLOSET!!
AND IT IS NOT EVEN THA SAME CLOSET!!!
I gave it my dead wife...but I don't think its working very well.
I'm very old now...and I'm sick of it...I stopped being afraid of it many many years ago.
I have tried to tell it off and get rid of it many many times.
New closet locations never work...its always there.

yours truly,
Thomas MothGurgle

Murder is born.

"You come out of that closet you horrid thing and do something about this horror!!!" Thomas demanded.

"What ever are you on about old broken hero?" Tha dark things words slither from his unseen vocal maker.

"Look from tha window you halfwit closet nightmare wanna be!" Thomas growled. "Look and see my beloved town I am sworn to protect is under invasion!"

"And this concerns me why exactly?" Tha shadow ponders out loud.

"Because they are like you...horror. But they are many! And it isn't going to be you in tha closest disturbing children if they have their way." Thomas explains.

"Ooohhh...this is a dire prospect indeed...can not....will not...have that." Tha things words curl like tha lips of a growling canine.

"I will require transport...you will be my host." Tha thing explains with what seemed like delight.

"I will do no such thing...that is preposterous!" Thomas complained.

"It is that or watch your beloved town you have fought for so many long years disintegrate before your panic stricken eyes" It says with a slight peppering of anger.

"Fine." Thomas concedes.

"Remember Thomas we will be together forever now. And despite all your efforts to protect this town...it will now be us who terrorizes it. But....better us than them....right?" It questions rhetorically.

Murder and Twerp meet tha world
&
Step into it and meet tha horrors.

—

Ghostly swirls...
...in tha old dried blood...
...onna crumpled piece of paper...
...I found in tha mud.

—

Red tinted sky...
...behind an ash filled cloud.
Decimation comes swift...
...and tha horror will not be loud.

—

Practically out tha door of his apartment Thomas grumbles "Lets go ya little twerp."
"We are a matched pair you and me." Tha child says with demented delight.
"Oh? How have you arrived at this conclusion?" Thomas questioned.
"You know my name." Tha child states.
"Your name is Twerp?" Thomas continues to question.
"Indeed" Twerp says with a grin that would sicken even tha most loving mother.
Thomas makes a ponderous face but refrains from saying anything.
Down tha stairs and out tha door they went into tha red lit nights ever growing horror...
...to stop it...
...by being worse.

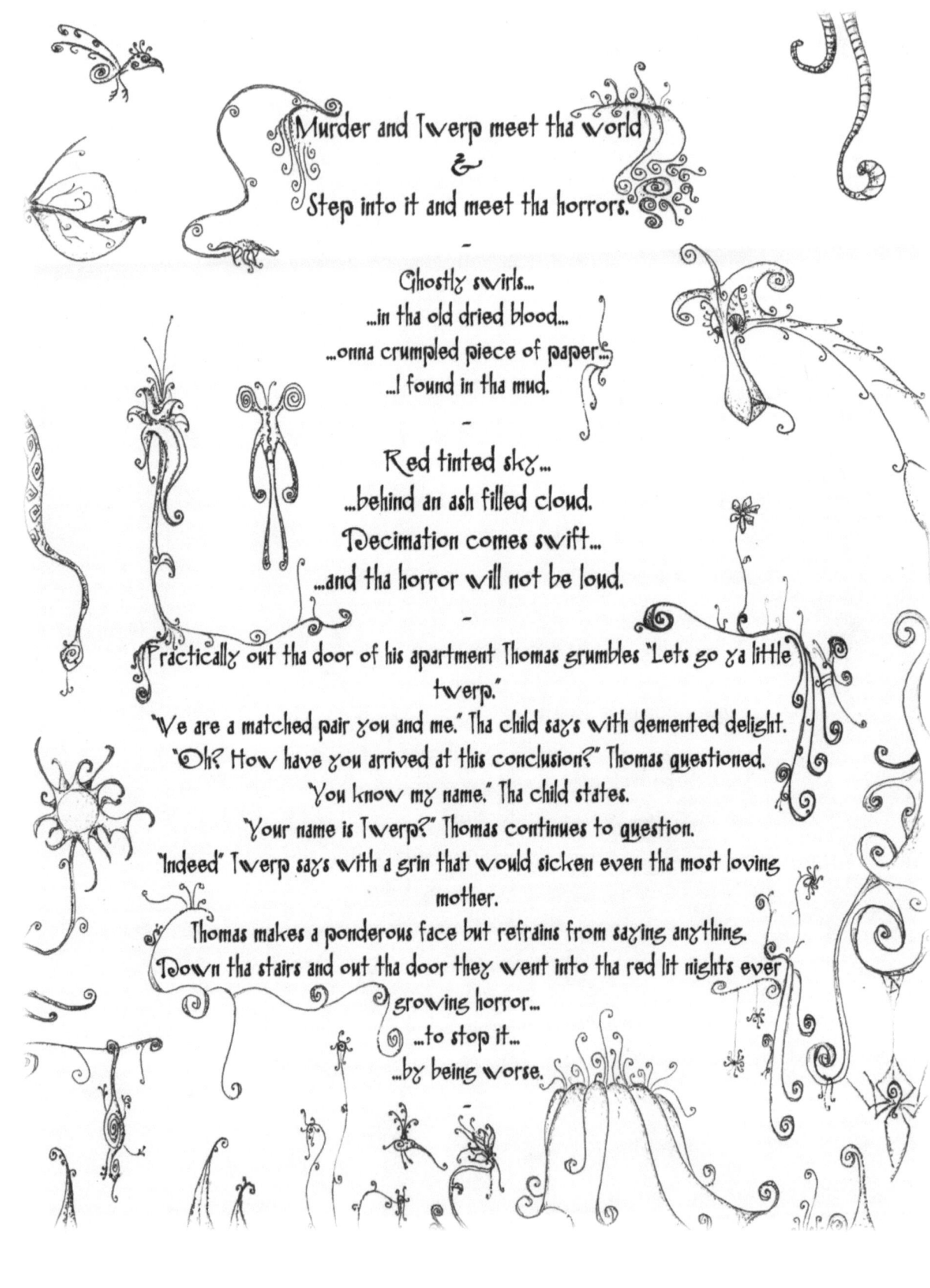

Tha Inn at tha End of tha Road

Put a hat on your hair if you so dare.

That horrid old hat...
Put her dreadful hat...
...right where I sat!!

Fancy box fancy box.
Inside is a clocks.
Clocks clocks goes tick tocks.
Along came a fox...
...who stealed tha box.
Can you not see?
Inside tha box...
...was a key.

At tha inn I read these words scratched into tha wood of a small café table.
I wonder who wrote them...or why.
Random uncontrolled babble?
Maybe on purpose to be cryptic?
Controlled babble for tha sake of some sort of art like purpose?
Information transmitted from elsewhere without being noticed disguised as one of tha latter?
Or noticed...and that's how it got scrambled?
Maybe it isn't scrambled and I just don't understand?
Maybe it scrambled itself to keep me from understanding?
Maybe it isn't there and I'm scrambled?
"How would you like your eggs?"
Scrambled.

www.ingramcontent.com/pod-product-compliance
Lightning Source LLC
Chambersburg PA
CBHW051052180526
45172CB00002B/613